Captive Light

The Life and Photography
of Ella E. McBride

NORTHWEST PERSPECTIVE SERIES

TACOMA ART MUSEUM

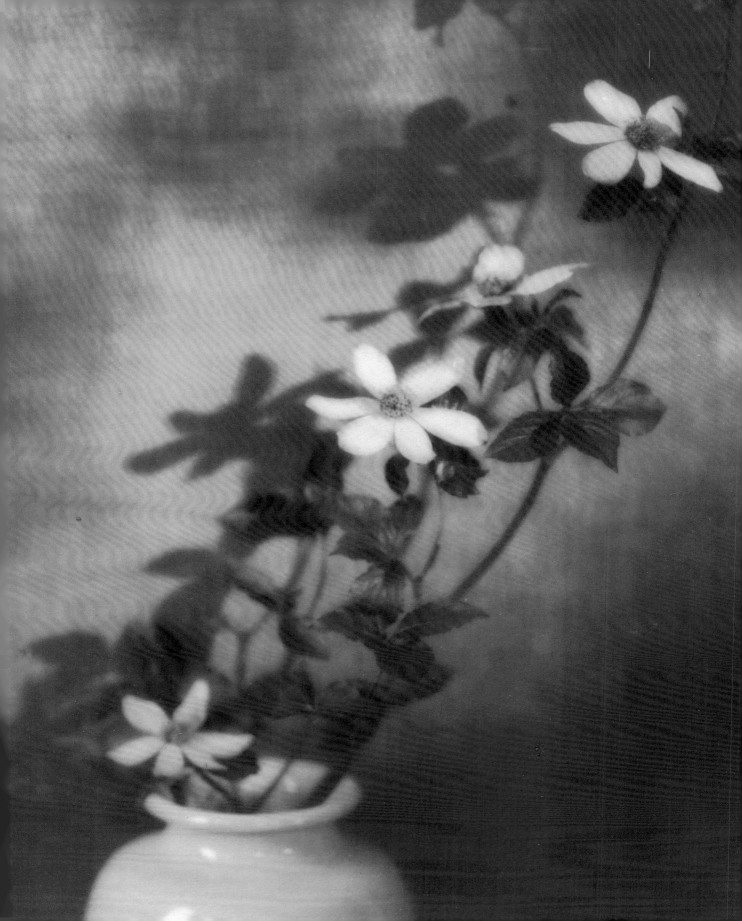

Captive Light

The Life and Photography of Ella E. McBride

MARGARET E. BULLOCK

DAVID F. MARTIN

TACOMA ART MUSEUM
TACOMA, WASHINGTON

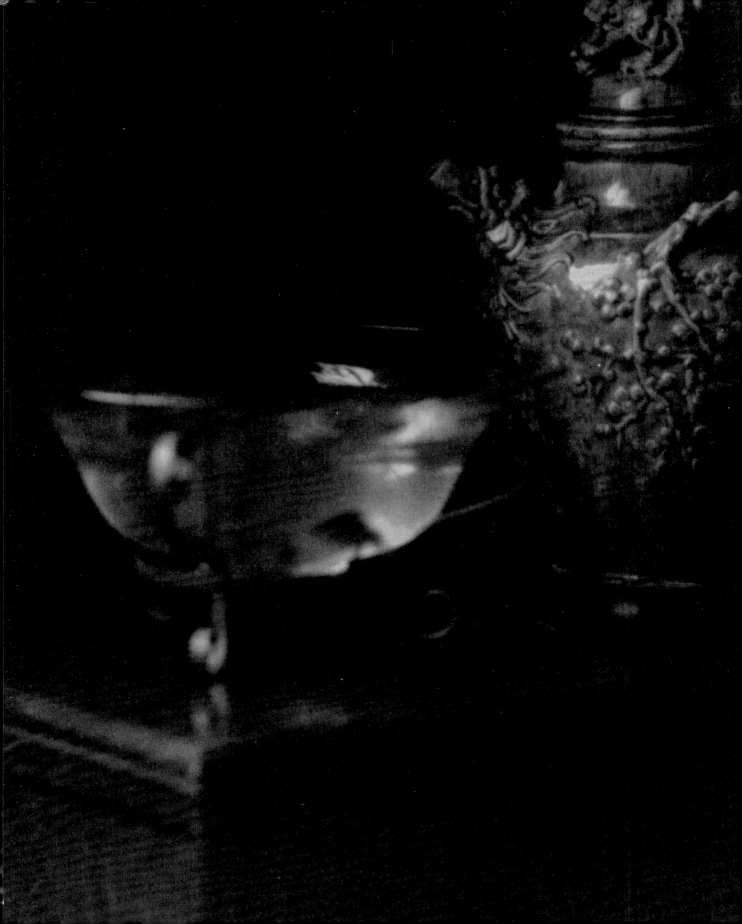

Contents

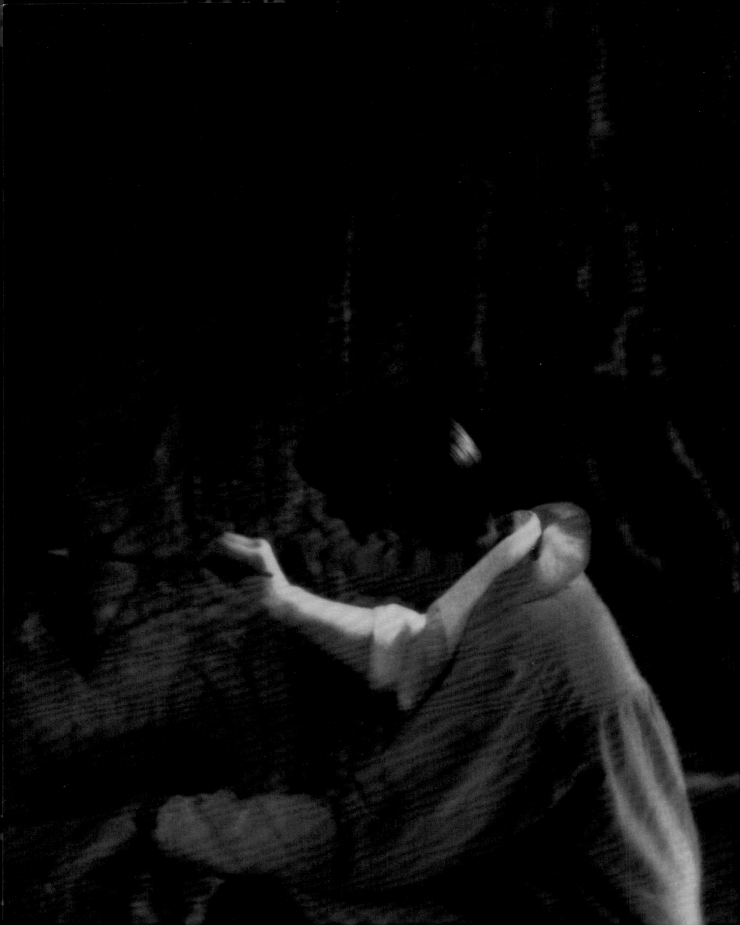

Foreword

The factors that awaken the artistic impulse in a person are as varied as artists themselves. For Ella McBride it was the photographers who worked at her portrait studio encouraging her to try taking some pictures herself. That experience, at the age of 59, sparked the discovery of a new passion and an explosion of creativity. In just over a decade, McBride produced a body of artwork that brought her international acclaim and created a lasting impact on the evolution of photography in the Northwest. That story and much of her work have, until now, been lost to time and circumstance, a fate this catalogue and related exhibition aim to correct.

Tacoma Art Museum's *Northwest Perspective Series* is dedicated to in-depth investigations of the works and careers of significant contemporary and historical regional artists. Each exhibition is accompanied by a publication to ensure that a lasting record remains and that TAM continues to enhance its value as a leading resource on the art of this region for colleagues and the general public. This is the fourth to rediscover and celebrate the career of a historical figure who was significant in his or her time but is not well known in ours. Projects such as this grow from TAM's core mission to explore, preserve, and share the artistic identity of the Northwest in all its richness and diversity.

These undertakings require a dedicated team. I'd like to recognize the original scholarship of curators David Martin and Margaret Bullock, who bring this artist and her work back to vivid life. David is a leading art historian on Northwest artists of the early 20th century, and Margaret is TAM's Curator of Collections and Special Exhibitions. They have been ably assisted by the museum's talented and dedicated staff. I am also grateful to my colleagues on the Board of Trustees whose steady support and belief in TAM's mission foster a thriving and vigorous institution dedicated to the art and artists of the Pacific Northwest and broader western region.

I particularly want to gratefully acknowledge the institutions and private collectors who have shared their artworks with us for the exhibition and honor the generosity of Jared FitzGerald, whose gift has provided funding support for this catalogue.

BILL DRISCOLL
PRESIDENT, TACOMA ART MUSEUM BOARD OF TRUSTEES

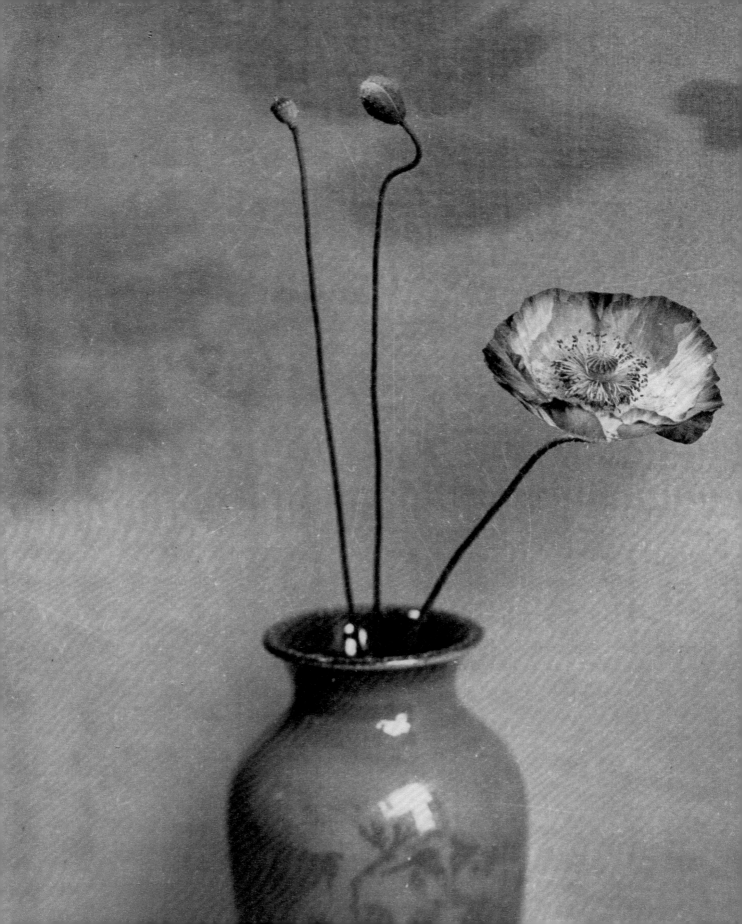

Curators' Acknowledgments

I would like to remember two friends who first told me about Ella McBride back in the 1980s. Robert D. Monroe (1918–1993) was then head of Special Collections at the University of Washington Libraries. He was an early scholar on the Seattle Camera Club and was instrumental in preserving and promoting the group's legacy. He relentlessly stressed the importance of my research on McBride. John D. McLauchlan (1909–1999) was a Seattle attorney and a very accomplished photographer in his own right. He was one of the leading forces behind the Seattle Photographic Society and was a tireless and generous supporter of local photography exhibitions. Jack was a friend of several important Northwest photographers, including Imogen Cunningham, Frank Asakichi Kunishige, Ella McBride, and Myra Albert Wiggins. His many stories gave me particular insight into their work and personalities. I still remember the day he first told me about Ella's amazing life and work and helped me to track down others who had known her and owned some of her photographs. So began my obsession with Ella McBride nearly 30 years ago.

There are several individuals who were critical to my research and I would like to thank them. First and foremost, Richard Anderson, son of Ella's business partner Richard H. Anderson, has been extremely supportive and generous with his time. He thoughtfully donated numerous McBride photographs to several art institutions in the Northwest and across the country to preserve her reputation. His siblings, David McBride Anderson, Susan Anderson Harris, and Liz Anderson Little, and niece Amy Johnson have also been helpful and supportive. I remember the late Mrs. Elizabeth H. Anderson, who met with me on numerous occasions to provide insight into Ella's life and personality. Ella's cousin Paul Hoerlein has given me access to family materials and spent time with me over the past 20 years providing family history and anecdotes that have helped me immensely. When I began my research, I received assistance from the late Walter Walkinshaw, whose father was Ella's attorney. Walt gave me sound advice and made connections for me as well. His wife, Jean Walkinshaw, has remained a great source of friendship, support, and encouragement.

I am indebted to the Tacoma Art Museum for producing this magnificent exhibition and catalogue. My coauthor and cocurator, Margaret Bullock, is such a wonderful person to work with, bringing extraordinary professionalism, knowledge, and insight to every project. This is our third and hopefully not last collaboration. Margaret is one of the great scholars in the Northwest

art community and shares my passion for bringing the accomplishments of Northwest women artists to light.

Thank you to the following professionals for their valuable assistance: Mathew Brock, Mazamas Library & Historical Collections Manager; my fellow Ella advocate, Nicolette Bromberg, Visual Materials Curator, Special Collections, University of Washington Libraries; Mick Gidley, emeritus professor of American Literature, University of Leeds; the late Olaf Bolm and Marilyn McLeod, Adolph Bolm Archive; Trevor Fairbrother, who gave early support and encouragement for the exhibition and study of McBride's work; Howard Giske, Curator of Photography, Museum of History and Industry, Seattle; Meg Partridge, the Imogen Cunningham Trust; Jade D'Addario, Librarian, Special Collections, and Jodee Fenton, Managing Librarian, The Seattle Public Library; Robert Fisher, Collections Manager, Wing Luke Museum of the Asian Pacific American Experience; and Dee Molenaar, mountain climber, artist, and writer.

Special thanks go to: Reiko Sunami Kopelson and John Sunami; Dennis and Annie Reed; Mary Ann Horning and Laura Wells; the board and staff of Cascadia Art Museum, where I serve as curator; and, as always, Dominic Zambito.

DAVID F. MARTIN

———

In August 2014 Tacoma Art Museum was approached by Christopher Cardozo, then of Curtis150, about taking part in a statewide celebration of the sesquicentennial of the birth of photographer Edward Sheriff Curtis. Since, at that time, TAM held no work by Curtis and various institutions were planning exhibitions about him, I began to explore other possibilities for contextualizing this well-known, and often polarizing, figure. As I read about him and his life's work on the massive 20-volume publication *The North American Indian*, what intrigued me was the mostly unheralded group of talented photographers who helped him both at his Seattle studio and on his travels across the United States. One standout among them was the enormously talented but mostly forgotten Ella McBride, whose evocative photographs clearly deserved to once again be internationally known, as they were in her own time.

The obvious partner to recruit was David Martin, a highly respected authority on 19th- and early 20th-century Northwest artists who has been researching McBride for several decades. I have had the privilege of collaborating with David on several other exhibitions in the past and the great pleasure of being friends and art history nerds together with him and his partner, Dominic Zambito, for many years. As always, it has been both a joy and a journey of discovery to work with him on this catalogue and exhibition.

In his acknowledgments, David individually recognizes many of those who have helped with various aspects of this project, so I gratefully add my thanks to his, notably to the

members of the Anderson and Hoerlein families and to Nicolette Bromberg, Visual Materials Curator, Special Collections, University of Washington Libraries.

I would also like to express my appreciation to several others who were of particular help to me: Phillip Karg, Supervising Librarian, The New York Public Library for the Performing Arts, Jerome Robbins Dance Division; Jayne Manuel, Registration Administrator, Loans Registration and Collections, Eve Schillo, Assistant Curator, Wallis Annenberg Photography Department, and Piper Wynn Severance, Senior Associate, Rights and Reproductions, Los Angeles County Museum of Art; and Ilona Perry, Northwest Room/Special Collections, Tacoma Public Library.

This beautiful catalogue is the result of the careful oversight and stewardship of Zoe Donnell, Exhibitions and Publications Manager at TAM; the insightful reading of editor Michelle Piranio; and the creative talents of designer Phil Kovacevich. Thank you all for your professionalism and passion for perfection.

Lastly, I express my deep appreciation for my colleagues at TAM who give these projects life: Rock Hushka, Deputy Director and Chief Curator, for his support and advocacy; Mary Brickle, Manager of Corporate and Foundation Relations, and Michelle Paulus, Major Gifts Officer, for obtaining financial support; and the multitalented group who give our exhibitions form and make coming into work every day a pleasure, including Faith Brower, Haub Curator of Western American Art; Tyson Griffin, Exhibitions Associate; Ellen Ito, Collections Management Associate; Ben Wildenhaus, Head Preparator; and Jessica Wilks, Associate Director of Curatorial and Head Registrar.

MARGARET E. BULLOCK
CURATOR OF COLLECTIONS AND SPECIAL EXHIBITIONS, TACOMA ART MUSEUM

Garden in the Darkroom

DAVID F. MARTIN

"I had only a high-school education, which, in the gay nineties,
was about as much schooling as most girls in the wild, woolly west
thought necessary for the few vocations open to them."
—Ella E. McBride[1]

Ella Etna McBride possessed a pioneering spirit that helped to shape the cultural history of
Seattle and the Northwest during the early 20th century. Born in Albia, Iowa, on November 17,
1862, she was the third of five children born to Samuel B. McBride (1837–1918) and America
McIntire McBride (1836–1922) (fig. 1). Her father first apprenticed as a blacksmith and then
developed other skills as a craftsman in stone and carpentry, specializing in cabinetry and wagon
making. He formed a business with his brother-in-law, Thomas Hampton, with whom he worked
as a stonecutter on the Sacramento State Capitol.

The McBride family began their long trek west in 1867 when Ella was still a child. At that
time the West Coast of the United States was accessible via the Isthmus of Panama. Their
journey started by heading east in a covered wagon to New York. From there, they boarded
a steamboat that delivered them to the isthmus, where they traversed the land by train to the
Gulf of Panama and the Pacific Ocean. They then boarded another steamboat that delivered
them to their destination, San Francisco. By 1870 the family was living in Wadsworth, Washoe
County, Nevada, where Samuel worked as a carpenter. In the early 1870s the family moved
first to Albany, Oregon, and finally in 1874 to Portland, where Samuel was able to support his
family making carriages and wagons, which were in high demand. By 1890 he had a successful
business, S. B. McBride & Co., and in 1902 established the Columbia Manufacturing Company.
A few years later he joined forces with junior partner Charles G. Irwin and renamed it Columbia
Carriage Mfg. Company. Samuel sold his interest in the company by 1910.[2]

Finally settling after an early peripatetic childhood, Ella performed popular songs at various churches and social functions in their community, instilling a sense of confidence and creativity that would serve her well as she matured. She graduated eighth grade from Portland's Harrison Street School and from Portland High School in 1882 (figs. 2, 3). As a young woman, Ella had several creative and athletic interests. She belonged to a Spanish guitar club and a bicycle club, and was often found outdoors hiking.

After completing high school, Ella attempted to further her education. She later recalled, "I wanted to go to college, but my parents could not afford it, and I chose teaching for my life's work."[3] After two years of extension courses, she earned a teaching certificate and began her career in 1884, educating fifth graders at Josiah Failing School in Portland. She remained in various teaching capacities until becoming principal of the Ainsworth School by 1894.

Around this time, she met a young Chinese immigrant her same age named Goon Dip (1862–1933) (fig. 4). He had left his native Guangdong Province as an eager 14-year-old boy in search of prosperity through the promise of the California gold rush. He initially arrived in Portland, where several family members had previously immigrated. The new land was not paved in gold as he had envisioned. Anti-Chinese racism and violence were on the rise and he proceeded with cautious optimism. His luck changed when he met and became a close friend of Ella McBride, who was teaching English at a local missionary school. The empathy she felt for her new friend's plight motivated her to persuade her parents to take the young man into their home as a housekeeper to provide him with a place to live and some basic income. She assisted Goon Dip in learning the English language and helped him adapt to the customs of his adopted

FIG. 1 McIntire family portrait, ca. 1908. From left: Ella's maternal aunt Annie McIntire Hampton; housekeeper (name unknown); Annie's daughter Blanche Hampton; and Ella's mother, America McIntire McBride. Courtesy of Paul Hoerlein

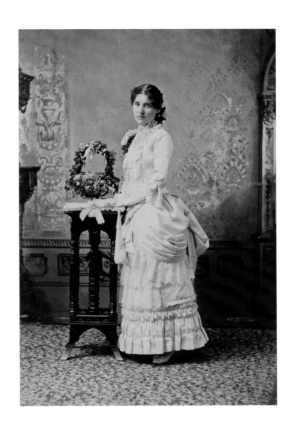

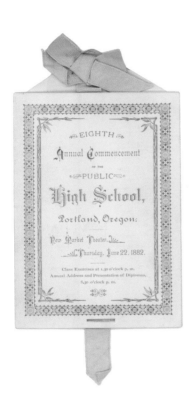

FIG. 2 Ella McBride's high school graduation program, 1882. Courtesy of Paul Hoerlein

FIG. 3 Ella McBride's high school graduation portrait, 1882, Towne Studio, Portland, Oregon. University of Washington Libraries, Special Collections, Acc. 2014-0221-03 Janet Anderson Collection, negative UW 38932

FIG. 4 Goon Dip, 1908. Unidentified photographer. Courtesy of Wing Luke Museum of the Asian Pacific American Experience

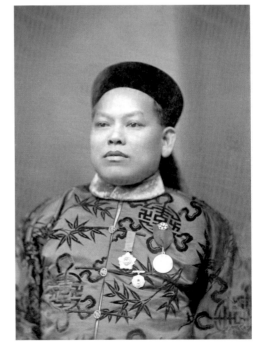

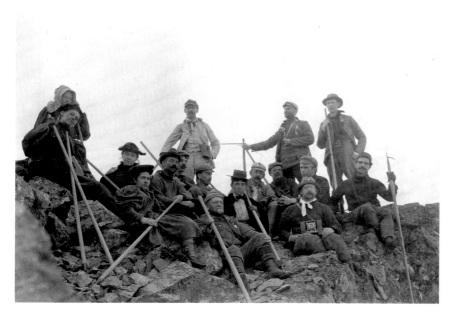
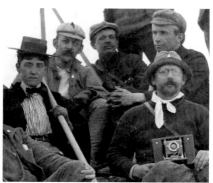

country. After spending a few years as a laborer in Portland and Tacoma, and faced with the increasing threats of violence against Chinese immigrants, he returned to his native land, where he married a woman named Chin Yook-Nui whose family had ties to the Pacific Northwest.

He attempted another move to the Northwest, returning to Portland without his wife. After several years of struggle, and with the assistance of his wife's prosperous family in Seattle, Goon Dip became an extremely successful businessman in Portland and Seattle, building his fortune as a labor contractor, developer, and retail businessman. His generous and community-minded spirit made him a highly respected figure in the region and he was eventually appointed Chinese Consul. He honored his beloved friend by naming his youngest daughter Ella McBride Goon in 1904.[4]

From a young age and throughout her teaching career, McBride established a love for hiking and exploring the great outdoors. She recalled, "My long vacations gave me opportunity to play a lot, and every summer found me in the mountains. My hobby was mountain climbing, and every year I was able to add one or two peaks to my list of conquests."[5] She joined the recently established Portland mountain-climbing association Mazamas in 1896 and served as historian from 1897 to 1899. Her first ascent was Mount Hood in 1896, followed by Mount Rainier in 1897 (figs. 5–8), Mount Saint Helens in 1898, Mount Hood again in 1901, Mount Adams in 1902, and Mount Baker in 1906. She went on to complete more than 37 climbs on the West Coast.[6] The 1897 Mazamas climb of Mount Rainier changed the course of her life. On this particular ascent, she met the noted photographer Edward Sheriff Curtis (1868–1952), who was leading the tour along with his wife and several distinguished mountaineers and scientists. They included

FIG. 5 EDWARD S. CURTIS (American, 1868–1952), Untitled, 1897. A party of Mazamas on the summit of Pinnacle Peak. Mount Rainier 1897 Collection, Mazamas Library and Historical Collections, VM1993-016 print03

This is the only known image of McBride and Curtis together. Curtis is lower right, holding his camera; Ella McBride is seated, center, to the left of Curtis (detail).

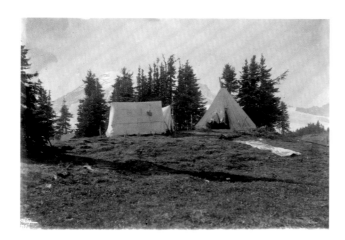

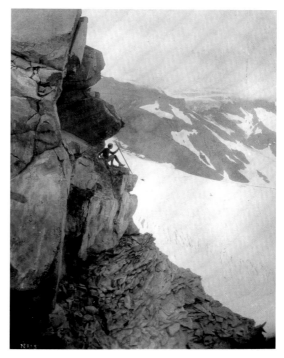

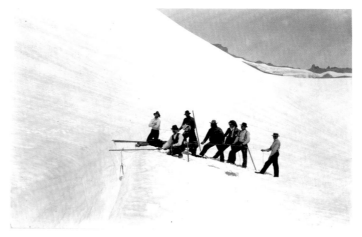

FIG. 6 EDWARD S. CURTIS
(American, 1868–1952), Untitled,
1897. Part of the camp used
by the Mazamas during the
1897 outing to Mount Rainier.
Mount Rainier 1897 Collection,
Mazamas Library and Historical
Collections, VM1993-016-005

FIG. 7 EDWARD S. CURTIS
(American, 1868–1952),
Overlooking the Cowlitz Glacier,
1897. Mount Rainier 1897
Collection, Mazamas Library and
Historical Collections, VM1993-
016 print37

FIG. 8 EDWARD S. CURTIS
(American, 1868–1952), *Rogers'
Rescue*, July 28, 1897. Gold-
toned gelatin silver print, 5 × 7 in.
Mount Rainier 1897 Collection,
Mazamas Library and Historical
Collections, VM1993-016 print33

This photograph is a later
reenactment of a rescue party
pulling Walter Rogers out of a
crevasse; his original nocturnal
fall occurred after the death of
McClure.

Philemon Beecher Van Trump, who, along with Hazard Stevens, became the first recorded individuals to climb the highest point of the mountain in 1870. Fay Fuller, the first woman to make the ascent in 1890, was also in the party. Another member of the party, Dr. Edgar McClure, chair of the chemistry department at the University of Oregon, lost his footing on the icy slope and died on the descent, marking the first known fatality on the mountain. McClure had been gathering measurements using mercurial barometers and it was from his data that the height of Mount Rainier was recorded at 14,528 feet. This measurement was the standard for 17 years and is now accurately calculated at 14,410 feet.

McBride later recalled the incident in a 1963 audio interview with mountaineering historian Dee Molenaar:

> Well, we started down and Professor McClure was perhaps the safest climber and had climbed more than anyone else. And he and I started down the mountain and he thought it was a shorter route, there was a shorter way that we could go straight down and then to the camp, and when we had gotten there, the others waited. There were five of us in this little party and the two of us started on ahead and the way got steeper and harder, and he said, "It's impossible, we can't go down this way," and he said he would stand in between me and the … [unintelligible] down, because he was very afraid of sliding, of slipping because it was very slippery … it was the brightest moonlight I ever saw and seemed brighter than daylight and he stood right below me and waited till I had turned around because it was pretty hard on that very steep place to turn around. And I turned around and started up and hadn't taken more than three or four steps up the mountain when I heard the most awful sound—sounded like a cannon going off—and I turned my head and I couldn't see Edgar anyplace, and I knew something awful had happened. What I thought, I thought a crevasse had opened and closed again and he was gone, shut in, so I called to Dr. [Davott] Connell, who was farther up and waiting for us, and called to him and said I thought something terrible had happened to McClure. And then when I got back where Connell was, we were all night calling back to the party that came from the camp and directing them as to where we were and see if they could find him. Well they found him in the rocks, the McClure rocks that were way down below.[7]

After witnessing this horrific incident, McBride pulled herself together and helped guide the remaining party to safety in a calm, authoritative manner. Curtis became very impressed with her physical and mental agility, and he recruited her to assist him on other mountaineering treks. He later recalled, "She was quite a mountain climber in the days of long ago. She failed to mention that she was a member of the large party of Mazamas who climbed Mt. Rainier and that she was the only woman who reached the summit unaided. As to Miss McBride and the Curtis Studio, she was a star helper for quite some years. During that time she lived with our family as one of us. She was a second mother to Beth and Florence [his daughters]."[8]

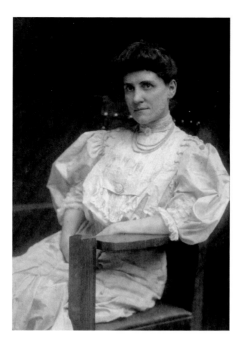

By 1905 McBride began assisting Curtis with his photography projects. While still performing her duties as a high school principal, she managed Curtis's exhibition at Portland's 1905 Lewis and Clark Centennial Exposition in the Forestry Building. Convinced that she could be a major asset to his career, he attempted to persuade her to quit her job and join the staff at his Seattle studio. As McBride later recalled,

> His field work kept him away from his Seattle studio, and he urged me to take over its management. I loved my schoolwork, and it took me some time to decide that I could give it up. He remarked that I would not always remain a spring chicken, and if I did not intend to teach all my life, it was time to think of a change. I really had intended to teach for the rest of my days. But the more I thought of a new undertaking, the greater became the appeal. However, it was much harder to give up the old career than it was to tackle a new one. So I decided while I was still a spring chicken (forty-one years old) I would make the break. I have been thankful always that I did, for a most beautiful and entirely new world has been opened to me.[9]

McBride moved to Seattle in 1907 to begin her association with Curtis as a clerk in his studio (fig. 9). Joining the staff was a talented young photographer who had also originally come from Portland, Imogen Cunningham (1883–1976) (fig. 10). She began working at the Curtis studio following her graduation from the University of Washington the same year. Unlike McBride, who

was not a practicing photographer at the time, Cunningham took full advantage of the opportunities afforded her, apprenticing under Curtis's master printer Adolph F. Muhr (1860–1913), who expanded her knowledge in the making of platinum prints.

In 1909 Cunningham was awarded a fellowship by her university sorority, Pi Beta Phi, to travel to Europe, where she studied photographic chemistry with Dr. Robert Luther at the Technische Hochschule Dresden. The following year she traveled to Paris, London, and New York before returning to Seattle, where she opened her studio at 1117 Terry Avenue on First Hill. She was now well on her way to developing a national reputation for her artistic pictorialist images of landscapes and figure studies. McBride, on the other hand, continued to assist Curtis as his manager and with building his reputation by operating his booth at the 1909 Alaska-Yukon-Pacific Exposition in Seattle. Before McBride and Cunningham arrived at the Curtis studio, he had faced the challenge of competition when the young San Francisco photographer Adelaide Hanscom (1876–1931) relocated to Seattle in 1906 and established a portrait studio downtown in the People's Savings Bank Building on the northeast corner of Second and Pike Streets.

Hanscom arrived as an acclaimed photographic artist following the destruction of her San Francisco studio in the 1906 earthquake and subsequent fire, and her presence was emphasized in the press as an important new addition to the nascent local arts community. Her reputation had been established through the groundbreaking photographic illustrations she produced for the 1905 publication of *The Rubáiyát of Omar Khayyám*. This innovative use of photography was something relatively new in American publishing and promised exciting possibilities.

Hanscom utilized sophisticated techniques such as the manipulation of the glass-plate negatives and prints by painting, incising, and overlaying multiple exposures to convey painterly effects. A gifted painter as well as photographer, she was selected to design the emblem for the Alaska-Yukon-Pacific Exposition. Like Curtis's, Hanscom's studio specialized in portraiture for prominent local families. In January 1908 she married Arthur Gerald Leeson, whom she had met in Seattle, and they moved to Alaska and later to California, where she died tragically in a car accident in 1931. Hanscom was in Seattle for less than four years, and yet during this short period, she exerted a lasting influence on the development of artistic photography in the city, especially in the coming decades when her work would influence McBride as well as her friends Wayne Albee (1882–1937) and Frank Asakichi Kunishige (1878–1960) (fig. 11), as discussed below.

McBride, Cunningham, and Hanscom all had ties to Portland and were also accomplished mountain enthusiasts. In 1907 another Oregon photographer, Myra Albert Wiggins (1869–1956), relocated to Washington State from her hometown of Salem. Wiggins was arguably the earliest internationally recognized artist from the Northwest. She began photography as a hobby in 1889 to supplement her first love, painting. She attended New York's Art Students League in 1891 and, along with painting, began a more serious study of photography, encouraged by her teacher and mentor, William Merritt Chase (1849–1916).

In 1892 Wiggins joined the Society of Amateur Photographers in New York and was included in their First Annual Members Exhibition organized by Alfred Stieglitz (1864–1946).

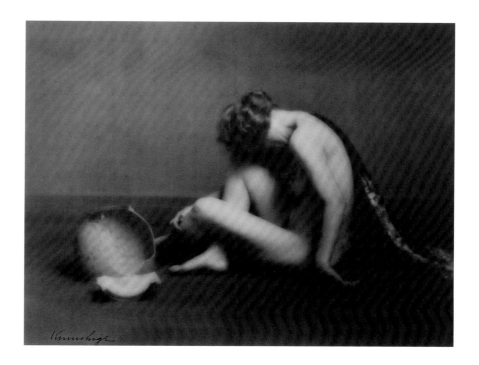

Her depictions of the Northwest landscape mystified East Coast audiences, who responded favorably to her work (fig. 12). Her career grew rapidly as she began to be included in numerous regional, national, and international exhibitions. Unlike her contemporaries, Wiggins never opened a commercial studio or used photography as a means to make a living.

In 1902 Wiggins's work was accepted into the prestigious annual exhibition of the Linked Ring Brotherhood in London. The following year she became an associate member of Stieglitz's Photo-Secession, guaranteeing her entry into some of the most prominent national and international exhibitions of the period. After returning to Salem, she became an advocate for art photography and began making works directly inspired by painters such as Jean-Baptiste-Camille Corot (1796–1875), James McNeill Whistler (1834–1903), and especially Johannes Vermeer (1632–1675).

In the spring of 1907, Wiggins moved to Washington and after a brief stay in Yakima, settled in Toppenish, where her husband had developed an agricultural business called the Washington Nursery Company. Like Cunningham, the elder and more experienced Wiggins created figure studies that were heavily influenced by the symbolist movement, with its emphasis on evocative, dreamlike imagery, as personified by Pre-Raphaelite painters and writers such as William Morris (1834–1896) and Dante Gabriel Rossetti (1828–1882). Wiggins also looked closer to home for her studies of the Northwest Native American population, something that Cunningham never explored, likely because of Curtis's dominant hold over the subject.

Wiggins's greatest achievement came in 1910, when Stieglitz included three of her works in the International Exhibition of Pictorial Photography held at the Albright Art Gallery (now the

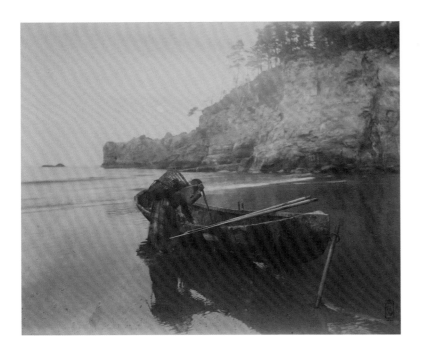

FIG. 12 MYRA ALBERT
WIGGINS (American,
1869–1956), *Unloading the
Catch*, 1898. Gelatin silver
print, 6 ³⁄₁₆ × 7 ¹⁄₄ in. Tacoma
Art Museum, Gift of the
Washington Art Consortium
through a gift of Safeco
Insurance, a member of
the Liberty Mutual Group,
2017.5.28

Albright-Knox Art Gallery) in Buffalo, New York, the only Washington artist to be so honored. This landmark exhibition was the culmination of Stieglitz's efforts on behalf of pictorialism and is considered to have been a key event in the establishment of photography as a fine-art medium in the United States. After the success of the Albright exhibition, Wiggins, like her mentor, produced less photography. Stieglitz concentrated on promoting modern art in the United States, and Wiggins returned to painting.

McBride proved to be an excellent asset to the Curtis studio, keeping track of his commissions and generating ideas to bring in potential customers. These included juried exhibitions of children's portraiture and competitions for the best images of beautiful young women as well as classical music concerts. The latter monthly studio teas were supported by various women's organizations and served to raise funds for Curtis's magnum opus, *The North American Indian*, a 20-volume tome published between 1907 and 1930. One of the musicians who performed frequently at the studio was the pianist Nellie Cornish (1876–1956), who opened her now-famous arts school in 1914, the same year that a devastating fire nearly destroyed the Curtis studio. With the high cost of Curtis's projects and the damage sustained because of the fire, the studio's finances began to suffer. Muhr, the backbone of the studio, had died in 1913 and left a gap that was nearly impossible to fill. Curtis's involvement in his studio diminished significantly as he became engrossed in his film project *In the Land of the Head Hunters*, which debuted in 1914.

After several unsuccessful attempts to purchase the failing Curtis studio with his daughter Beth, McBride went into partnership with photographer Edmund Schwinke (1888–1977), who

had been an important associate of Curtis's, assisting him with his movie as well as in ethnographic studio recordings and business dealings. Schwinke and McBride opened the McBride Studio as announced in the local press in October 1915 (figs. 13, 14). They were joined a few years later by Wayne Albee (fig. 15), who would provide the aesthetic direction the studio required. Albee had a studio in Tacoma named Ye Likeness Shop, which remained in operation until 1916. The following year, he moved to Seattle and briefly operated a studio at 706 Pike Street until 1918, when he went into partnership with McBride and Schwinke. McBride had not yet developed her own photographic skills and relied on Albee's talents to offer high-quality portraiture to potential customers.

One of the mainstays of the Curtis studio, Josuke Kuniyasu (1879–1966), had arrived in Seattle in 1899 and began working there in 1902, remaining a faithful employee until the studio closed in 1920. He moved back to Japan in 1924.[10] Another Issei photographer, Frank Asakichi Kunishige, also got his start at the Curtis studio, although he was there for only a very brief time. Through Kuniyasu, Kunishige had accepted a position with Curtis's studio upon his arrival in Seattle in 1917. The two men had gone to school together in Japan and had relatives in common. Kunishige had arrived in the States in 1896, settling initially in San Francisco. After attending the Illinois College of Photography in Effingham from 1911 to 1913, he returned briefly to San Francisco and opened a studio on Fillmore Street, before moving to the Northwest.

By 1919 Kunishige was preparing for the closing of the Curtis studio the following year. He accepted a position with the McBride Studio and became an important member of her staff. With Kunishige, Albee, Soichi Sunami (1885–1971), and Shuji Nagakura (dates unknown) as her main photographers, McBride's studio flourished. They photographed the important artists, dancers, and events at Nellie Cornish's school, producing press photos and using some of the performers as models for their individual pictorialist work. The Cornish School of Allied Arts (now the Cornish College of the Arts) was rapidly becoming internationally renowned for its dance department and developed a reputation for fostering creativity and experimentation. Iconic dancers of the period such as Anna Pavlova, Ruth St. Denis, and Ted Shawn visited the school, and its faculty included Martha Graham, Adolph Bolm (see plate 41), and Michio Itō. Many of these dancers posed for McBride's photographers, who gained wide acclaim for their unique and sophisticated studies.

Later in life, McBride would mention that although she had a long friendship with Curtis and worked for him for many years, her interest in making her own photography came from Albee (figs. 16, 17), who, she claimed, gave her "the photography fever." In 1927 she recalled her own start as an artistic photographer: "One noon … while my employees were out to lunch, I decided to try my luck, just for the fun of it. I put two lilies in a shallow bowl. One was a fresh bloom, the other wilted and dying. When the picture was developed I named it 'Life and Death' and sent it with three successive studies to the Royal Photographic Society of Great Britain. The Society accepted 'Life and Death' and two of the other flower portraits and hung them in its 1922 salon."[11] The acceptance of her work into this prestigious salon signaled a promising

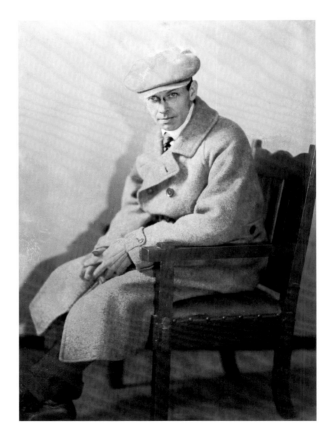

FIG. 13 McBride Studio business card, ca. 1924. University of Washington Libraries, Special Collections, PH Coll 551 McBride Studio Collection, UW 38944

FIG. 14 McBride Studio advertisement, *Seattle Daily Times*, October 15, 1915, page 14. Courtesy of The Seattle Public Library

FIG. 15 SOICHI SUNAMI (Japanese, 1885–1971), *Wayne Albee*, 1921. Scanned from the original glass-plate negative. Courtesy of the Estate of Soichi Sunami

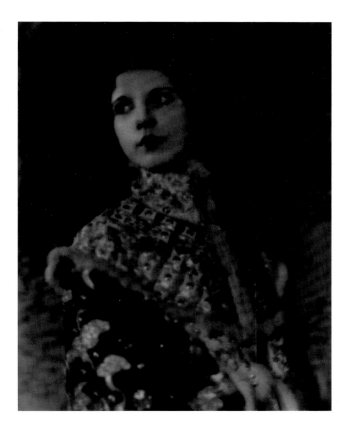

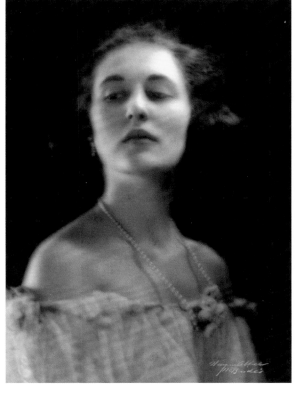

FIG. 17 WAYNE ALBEE (American, 1882–1937) for the McBride Studio, *Mary Ann Wells*, ca. 1920. Gelatin silver print, 10 ¾ × 8 in. Courtesy of Mary Ann Horning and Laura Wells

Mary Ann Wells (1894–1971) was a major figure in Seattle's dance history. She founded the dance department at Cornish School of Allied Arts in 1916 and remained there for seven years until opening her own legendary dance studio, which operated until 1958. Among Wells's numerous successful students were Gerald Arpino and Robert Joffrey, founders of the Joffrey Ballet.

FIG. 16 WAYNE ALBEE (American, 1882–1937), *The Mandarin Coat*, ca. 1925. Gelatin silver print on tissue, dimensions unknown. Collection of Dennis Reed and Amy Reed

beginning to her career as a pictorialist since there were thousands of international entries submitted and only 154 selected. Twelve of these, including her three floral studies, were by American photographers.

McBride had actually first exhibited her work in October 1921, in the North American Times Exhibition of Pictorial Photographs sponsored by the Seattle Japanese newspaper of the same name. She was the only woman and the single Caucasian represented in the exhibition. This was followed a few days later by her inclusion in the more prominent annual Frederick & Nelson Salon, where three of her eight floral photographs won honorable mentions in the competition. Frederick & Nelson was a prestigious Seattle department store founded in 1891. Their photographic salon provided a valuable exhibition opportunity, as Seattle's art museums had not yet been established. The salons became internationally recognized during their short existence from 1920 to 1925. Several important photographers exhibited in them, including Edward Weston (1886–1958) and Margrethe Mather (1886–1952), both of whom won awards in the first exhibition, along with Myra Wiggins and newcomer Soichi Sunami.

In 1922 eight of McBride's photographs were selected for the third Frederick & Nelson Salon, to which she submitted mostly landscape and figure studies, including a portrait of Kunishige. Her only floral entry was the aforementioned *Life and Death* (ca. 1921; plate 7). McBride's love of flowers originated in part from her mountain-climbing days; she recalled the beautiful spring display on Mount Rainier: "It was just a blaze of flowers, you couldn't step without stepping on flowers or pitch a little tent without the floor covered with flowers."[12] She would exhibit in two additional Frederick & Nelson Salons in 1923 and 1925. From this auspicious beginning and at nearly 60 years of age, she entered more regional, national, and international competitions with increasing success.

McBride's achievements as a pictorialist owed something to her becoming an active member of the Seattle Camera Club (fig. 18). The SCC formed in 1924 and held its first exhibition the following year, filling the gap left by the ending of the Frederick & Nelson Salon after six successful exhibitions. Although she was not a founding member, McBride joined the SCC shortly after its formation. She was one of their most accomplished members, and ranked among the most exhibited photographers in the world. The SCC's figurehead and key founder was the indefatigable Dr. Kyo Koike (1878–1947), who became an important advocate for artistic photography and maintained a regular presence in pictorialist salons throughout the world. Koike's poetic landscapes of the Northwest were inspired by his love of nature and reflect his knowledge of Japanese compositional elements, which he incorporated so successfully in his work.

McBride, like some of her colleagues, would sometimes include figure studies along with her floral subjects, often using dancers and artists as models for her compositions. Her circa 1924 study of Pavlova, *The Incomparable*, shows her ability at its finest (page 65). Unlike Koike's, McBride's subject range rarely included landscapes and no mountain studies by her are known to exist. Instead, her subject matter reflected intimacy and a skilled design sense.

The artistic work coming out of McBride's studio would initiate a national impact when her assistant Sunami relocated to New York in 1922 to pursue studies at the Art Students League. Because of his formidable talent, his reputation quickly spread to several well-connected

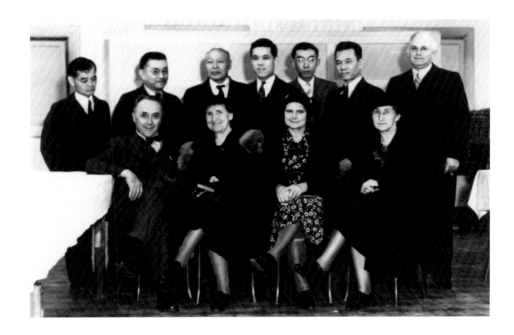

FIG. 18 Seattle Camera
Club members and guests,
ca. 1928. Standing from left:
Frank Asakichi Kunishige,
Dr. Kyo Koike, H. Ihashi,
I. Kambara, N. Ike, Yukio
Morinaga, Charles A.
Musgrave. Seated left to
right: Dr. D. J. Ruzicka, Ella
McBride, Mrs. Ruzicka, and
Mrs. Musgrave. Dr. Drahomir
J. Ruzicka (1870–1960) of
New York was a leading
pictorialist photographer
and an avid supporter of
the SCC. Photograph by
Harry A. Kirwin. University
of Washington Libraries,
Special Collections, PH Coll
0262 Kyo Koike Photograph
Collection, UW 29046

members of the New York art world. He was recruited as the staff photographer for the newly opened Museum of Modern Art in 1930, remaining there for the next 38 years. His MoMA work was augmented by a continuing interest in modern dance. Through his initial contacts at the McBride Studio, Sunami created one of the greatest bodies of work in dance photography in the United States (fig. 19).

McBride's own achievements were noted in numerous photographic publications of the day and her work was mentioned quite often as among the best in many of the reviews of the international salons that displayed her work. The *Town Crier*, Seattle's most prominent local cultural publication of the time, proudly listed her accomplishments in 1925:

Speaking of honors, they have been hanging Miss McBride again. This time it was in the Photographic Salon at Bridge of Allan, near Glasgow, Scotland, and the other day she received a handsome diploma and a still handsomer letter of congratulations from the All-Highest because she was the only woman of America represented at the very important exhibit, and because her work was also among the fifty choicest photographs selected from an untold number submitted.... Another item on this subject comes to mind. In the January number of a Paris journal there were four reproductions of pictorialist photographs which had been shown in the Salon Photographie, and one of the four was "Life and Death" by Miss McBride—a study which the New York Herald of Paris pronounced as full of symbolism. On the cover of the journal were the names of the four winners, and to Miss McBride's name was attached the magic words—Seattle, U.S.A.[13]

FIG. 19 SOICHI SUNAMI
(Japanese, 1885–1971), *Ruth
St. Denis in "Tagore Poem,"*
1929. Gelatin silver print,
9 1/8 × 7 in. Courtesy of the
Estate of Soichi Sunami

By now she had exhibited and won honors in international competitions in England, Belgium, Spain, France, Austria, and Canada.

McBride also achieved special notice from one of the most successful camera clubs in the United States at the time, which was in Buffalo, New York. In a review of the Buffalo Camera Club's 1925 salon, a critic highlighted the SCC entries: "Especially unusual and interesting in this exhibition was the work of the Seattle Camera Club, a Japanese organization whose pictures gave a most unusual insight into the effect of the impact of Eastern minds on Western methods."[14] McBride certainly displayed the influence of Japanese art in her compositions; it was inevitable considering that most of her associates were Issei. Her floral studies were contemporaneous with those of Buffalo Camera Club member Clara Sipprell (1885–1975), who had previously exhibited six nonfloral studies in the 1923 Frederick & Nelson Salon in Seattle.

McBride's pictorialist works were widely recognized and illustrated in several important publications of the day, including the *Annual of American Photography*; *Camera* (Switzerland); *American Photography*; *Amateur Photographer*; *Fotokunst* (Antwerp); *Focus* (Holland); and *Photographic Journal*, which was the official monthly publication of the Royal Photographic Society, Great Britain. McBride was one of only three women associated with the SCC; the others were Miss Y. Inagi, of whom almost nothing is known, and Virna Haffer (1899–1974), who had her own portrait studio in Tacoma and like McBride had a brilliant Issei photographer, Yukio Morinaga (1888–1968), as her main assistant.

In 1926 McBride moved her studio to a larger location in downtown Seattle's Douglas Building at Fourth and Union. The opening in June of that year was a social event, and

FIG. 20 ELLA E. MCBRIDE,
Bertha Landes, ca. 1924.
Gelatin silver print,
9 ½ × 7 ½ in. University of
Washington Libraries, Special
Collections, PH Coll 1037,
Album 2 Ella McBride and
Anderson Soroptimist Photo
Albums, UW 38931

McBride's close friend Bertha Knight Landes (1868–1943) served refreshments. Landes was then mayor of Seattle, the first woman to hold that office in a large American city (fig. 20). Landes and McBride were cofounders of the Seattle Chapter of the Soroptimist Club in 1925. The organization consisted of professional women in the community, including physicians, architects, artists, and others, who supported one another's career objectives (figs. 21, 22). The networking and social functions (figs. 23, 24) provided mentorship to women entering the initial phases of their professional careers. McBride and Landes developed long associations with the organization and both would serve as president.

McBride's studio was now a well-established business. In addition to her male Japanese assistants, she hired a young apprentice named Betti Morrison (d. 1975). Morrison was a creative and well-connected young woman from a prominent family in Tacoma who displayed some talent in photography (fig. 25). Around 1924 she was conscripted to pose for Kunishige and McBride in the studio wearing a beautiful couture hat. Kunishige's *Betti* (ca. 1924; fig. 26) became known through reproductions in international exhibitions and publications, including one of the leading art journals in Paris, *Revue du Vrai et du Beau*, in December 1924. Morrison did not continue with her photographic career and instead chose to marry and raise a child. After a divorce, she married Dr. Richard Fuller (1897–1976) in 1951. Fuller was an old friend she had known through the Seattle Fine Arts Society and as the cofounder and director of the Seattle Art Museum, which opened in 1933.

Frequently, many of the members of the SCC, including McBride, would photograph the same subjects at the same shoots, working side by side. McBride had a very nice collection of

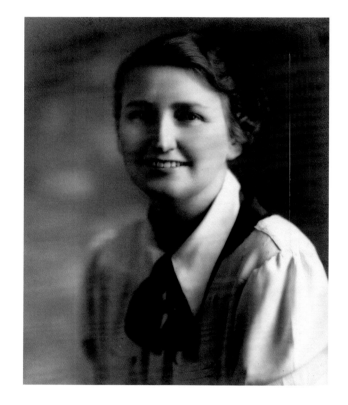

FIG. 21 ELLA E. MCBRIDE, *Dr. Mabel Seagrave*, ca. 1924. Gelatin silver print, 6 1/4 × 4 1/2 in. University of Washington Libraries, Special Collections, PH Coll 551 McBride Studio Collection, UW 38945

Dr. Mabel Seagrave (1882–1935) was a prominent member of the Seattle Soroptimist organization. She attended Wellesley College and received her medical degree from Johns Hopkins University in 1911. She was decorated by the French government for her work in France during and after World War I, and upon her return became a prominent physician in Seattle.

FIG. 22 ELLA E. MCBRIDE, *Elizabeth Ayer*, ca. 1924. Gelatin silver print, 9 1/2 × 7 1/2 in. University of Washington Libraries, Special Collections, PH Coll 1037, Album 1 Ella McBride and Anderson Soroptimist Photo Albums, UW 38930

Elizabeth Ayer (1897–1987) was a prominent Seattle architect and friend of Ella McBride. Like many members of the Seattle Soroptimist organization, she was a pioneering female professional, being the first woman to graduate from the architecture program at the University of Washington and the first woman registered as an architect in Washington State.

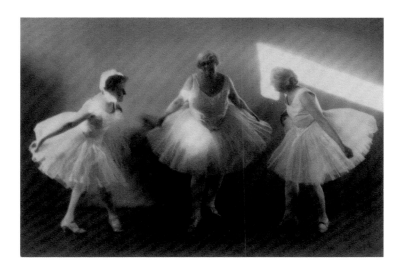

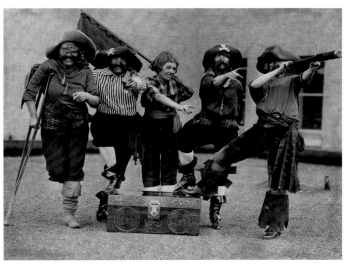

FIG. 23 McBride Studio, *The Ballet Dancers*, 1931. Gelatin silver print, 4½ × 6½ in. University of Washington Libraries, Special Collections, PH Coll 551 McBride Studio Collection, UW 38943

This photograph depicts a scene from a comical program for the Seattle Soroptimists, 1931, directed by Mary Ann Wells. From left: Ella McBride, Lee Ellenwood, and Lena Hemphill.

FIG. 24 Photographer unknown, Production of *Treasure Island* for the Soroptimist Club, September 29, 1926. Gelatin silver print, 7½ × 9½ in. University of Washington Libraries, Special Collections, PH Coll 563 Portraits Collection, UW 38942

From left: Lois Sandall as Long John Silver, Ella McBride as Darby McGraw, Jessie Kelly as Jim Hawkins, Rose Morgan as Black Dog, and Mary Ann Wells as Captain Billy Bones.

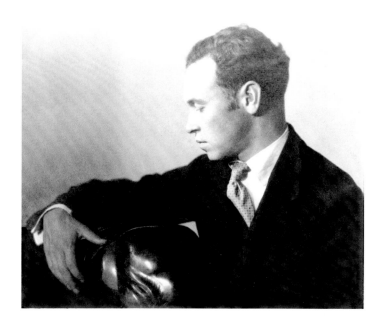

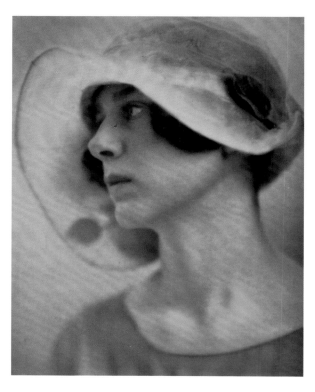

FIG. 25 ELIZABETH "BETTI"
MORRISON (American,
d. 1975), *Thomas Handforth*,
ca. 1926. Gelatin silver print,
7 × 8 in. Northwest Room/
Special Collections, Tacoma
Public Library. Photograph
file repaired with Photoshop

FIG. 26 FRANK ASAKICHI
KUNISHIGE (Japanese,
1878–1960), *Betti*, ca. 1924.
Gelatin silver print on Textura
tissue, 9 ½ × 7 ⅛ in. Private
collection

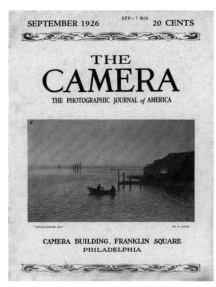

Chinese antiques that had been given to her by her old friend Goon Dip. He had managed the Chinese pavilion at the Alaska-Yukon-Pacific Exposition and gave McBride many of the objects that had been on display. Several vases, jars, and a large wooden elephant sculpture were often used as props in the McBride Studio, imparting a sophisticated and exotic element to the studies (fig. 27). In Chinese culture, the elephant represented wisdom and strength, attributes that Goon Dip no doubt found abundant in McBride.

By 1926 McBride and her friends in the SCC enjoyed an escalating national and international presence. That year they were so prominent that the New York Public Library requested a subscription to their bulletin *Notan* to keep track of their activities and for archival purposes. This was in addition to being featured in the September 1926 issue of *The Camera: The Photographic Journal of America* (fig. 28), which contained an article about the SCC and highlighted 18 reproductions, including McBride's *The Magic Vase* (ca. 1924; plate 36).[15]

As a member of the Associated Camera Clubs of America, the SCC also hosted numerous traveling exhibitions by clubs from Los Angeles, Cincinnati, Newark, and other major cities as well as sponsoring solo exhibitions by some of the clubs' membership. The SCC developed ties with other regional venues such as the Seattle Public Library, which cosponsored the 1925 exhibition *Prize-Winning Prints in the Fifth Annual Competition*, organized by *American Photography* magazine. The traveling exhibition offered examples of some of the finest pictorialist works by American and international photographers, including the renowned locals.

In the February 11, 1927, issue of *Notan*, Koike inserted a small paragraph in a review of the club's 1926 activities. "In conclusion," he wrote, "I shall not omit to tell you that we were given the

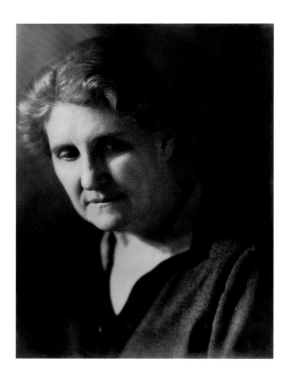

FIG. 29 Attributed to FRANK ASAKICHI KUNISHIGE (Japanese, 1878–1960), *Ella McBride*, ca. 1925. Gelatin silver print, 9 ⅝ × 7 ¼ in. University of Washington Libraries, Special Collections, Acc. 2014-0221-03 Janet Anderson Collection, UW 38933

privilege to hold the Photo-Era Trophy Cup for one year and that The Camera, September, 1926, was the Seattle Camera Club number; but I shall not take the time or space to tell how many prints by our members were used as illustrations or appeared in various books and magazines throughout the world. They are so many and I have told you before in our monthly bulletin. We are happy to have made a new record and wish our members increased success in the coming year." Koike, in his typically humble fashion was able to credit his own accomplishments as well as those of his fellow SCC members.

Winning the Photo-Era Trophy Cup in 1926 was an impressive achievement. It was the first year that the important photographic journal presented this prize to an American or Canadian camera club whose members had achieved the most successful winning entries in their monthly competitions. In addition to illustrating the incredible diligence and success of the SCC, this honor brought individual acclaim and gave the region a sense of cultural pride.

The year 1927 was especially successful for McBride (fig. 29). The *American Annual of Photography*, listing her activities from the previous year, identified her as the fourth most-exhibited pictorialist in the United States and Canada with 71 prints shown in 21 salons. In May two of her photographs, *Eryngium—An Arrangement* (ca. 1924; plate 34) and *Poppies* (1921; plate 4), were accepted into the First International Photographic Salon of Japan (fig. 30). This was followed by two known solo exhibitions consisting of 30 of her best prints shown at the California Camera Club, San Francisco, in August and at the Portage Camera Club, Akron, Ohio, in November. Her photograph *Dogwood* (ca. 1921; plate 9) appeared in the November 1927 issue of the Royal Photographic Society's *Photographic Journal*.

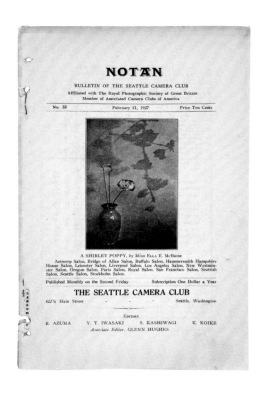

FIG. 30 Exhibition label from the First International Photographic Salon of Japan, 1927, affixed to the verso of McBride's photograph *Poppies*. Private collection

FIG. 31 Cover of *Notan*, February 11, 1927, listing some of the salons that included McBride's photograph *A Shirley Poppy*. University of Washington Libraries, Special Collections, UW 29137

Locally, the *Town Crier* published several of McBride's pictorialist photo-essays, as did the University of Washington's *Tyee* yearbooks in 1926 and 1928. Between 1925 and 1927, McBride's most famous image, *A Shirley Poppy* (1925; plate 43), was exhibited in no fewer than 19 international salons (fig. 31).

By 1928, at the peak of her success, McBride was beginning to slow down on her exhibition production. Well into her sixties, she produced very few new exhibition prints, and between 1928 and 1929 she exhibited only two prints in two salons. On January 28, 1928, the SCC held a farewell party for her dear friend Wayne Albee before his move to California, where he initially lived in La Jolla and later in San Diego. McBride had lost her most important influence and close associate.

In June 1929 the SCC's fifth exhibition was held at the Art Institute of Seattle, a prestigious venue whose exhibitions rarely included photography. Once again, the SCC exhibition showed hundreds of works by local and international photographers. The Art Institute and its antecedents, the Washington State Art Association and the Seattle Fine Arts Society, were the city's major cultural venues and sponsored the leading local, national, and international visual art shows until the founding of the University of Washington's Henry Art Gallery in 1927 and the Seattle Art Museum in 1933. In its final year, the SCC was the leading and most acclaimed artists' organization in the state, evidenced by the major international recognition of its membership.

In the final edition of *Notan*, published on October 11, 1929, just weeks before the disastrous Wall Street crash, Koike once again outlined the membership's accomplishments and

related news of their activities. Under the simple heading "Farewell," he explained the club's demise:

> We decided to disband our Seattle Camera Club because of non-activities and financial difficulties of most of the members. Our organization was in flower at one time, but its autumn has come and it is withered now. We owe our success in the past to all of our friends here and there and we are sorry we cannot stand any longer even with their encouragement. We should not keep our group for the name only, but rather we shall be separated until the time has come again for us to join once more. There is no more Seattle Camera Club and neither this monthly bulletin, Notan. We express our hearty thankfulness to the friends, contributors and advertisers, who helped us and stimulated us in every way during our existence. Good-bye everybody. We wish you good luck.

Two months after the demise of the SCC, Koike was given a solo exhibition at the Art Institute of Seattle from December 5, 1929, through January 6, 1930. The final International Exhibition of Pictorial Photography sponsored by the SCC ran from June 4 to September 20, 1930, ending one of the most successful series of regional photographic exhibitions up to that date. Koike was able to maintain his international reputation throughout the Great Depression as his physician's salary provided enough income to sustain his avocation.

McBride and Kunishige relied on the income generated by her studio, which continued to flourish despite the economic downturn. Although McBride was substantially diminishing her production of pictorialist works, she was honored with a solo exhibition at the Art Institute of Seattle from January 7 through January 18, 1931. Despite the short run of the exhibition, she gave a lecture titled "Photography: Its Place in Art" to support the medium and to offer inspiration for up-and-coming photographers in the community. Her friend Myra Albert Wiggins had also been given a solo exhibition at the Institute just three years earlier in 1928.

In 1932 McBride moved into the recently constructed Loveless Studio Building at 711 Broadway East on Seattle's Capitol Hill (fig. 32). The beautiful Tudor Revivalist structure attracted several artists, including Wiggins, whose negatives McBride would occasionally print. At this time, McBride took on a new business partner, Richard H. Anderson (1908–1970), who had moved to Seattle in 1925 (figs. 33, 34). He had attended photography school in Philadelphia and apprenticed at the renowned Bachrach Studios. A commercial photographer, he specialized in children's portraiture, a mainstay for any studio's success. McBride, who had never married, became part of Anderson's family, being a surrogate grandmother to his children much as she had with Curtis's offspring when she first moved to Seattle. No records of McBride having any romantic relationships with men or women have survived.

Over the next 30 years, McBride and Anderson maintained their reputation as one of the leading studios in Seattle. After the SCC folded, McBride remained active in commercial photography although her exhibition days were behind her. She continued her advocacy on behalf

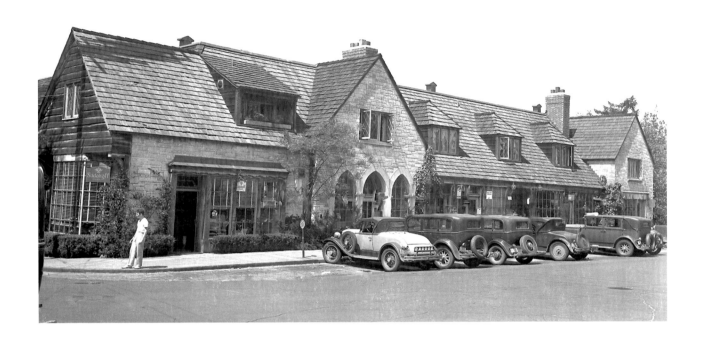

FIG. 32 Loveless Studio Building in Seattle, 1937. Unidentified photographer. Image provided by Puget Sound Regional Archives, Bellevue, Washington. Photograph file repaired with Photoshop

The Loveless Studio Building was home to the McBride Studio and that of photographer Myra Albert Wiggins.

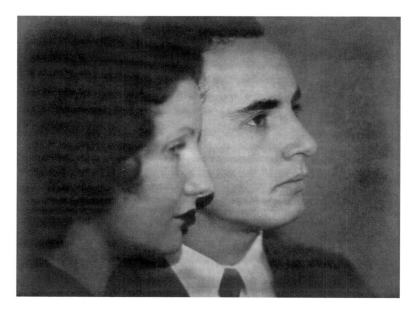

FIG. 34 FRANK ASAKICHI KUNISHIGE (Japanese, 1878–1960), *The Living Masks*, ca. 1930. Gelatin silver print on Textura tissue, 9 ¾ × 12 ¼ in. Courtesy of The Seattle Public Library, Frank A. Kunishige Collection 367924_35

Richard H. Anderson was the male model for this photograph. The woman is thought to be his sister, Lisa Smithson.

FIG. 33 Richard H. Anderson, ca. 1933. Unidentified photographer. Courtesy of Richard Anderson

of the medium by lecturing at various cultural institutions and social organizations such as the Women's University Club, where she gave a lecture titled "Photography as an Art" on April 23, 1937. Later that year, she lost her dear friend and mentor Wayne Albee, who died in his sleep at the age of 55.

With Anderson successfully maintaining the studio, McBride finally had some time to travel. In 1938 she went to Europe for several months with some of the women from the Soroptimist Club. The following year she spent the summer traveling to the East Coast to attend the Photographers' Association of America convention in Buffalo and the New York World's Fair. From there she returned to the West Coast, taking a steamship through the Panama Canal and stopping in Acapulco and Los Angeles.

She was now approaching 80 but continued to work in her studio with Anderson. Among the few remaining former members of the SCC, several had returned to Japan before World War II and were never heard of again. Others, after struggling through the debilitating economic loss of the Depression, had a new and more insidious problem to deal with when President Franklin D. Roosevelt signed Executive Order 9066 on February 19, 1942. This act, a terrible stain on an otherwise successful presidency, declared the West Coast a military zone and led to the involuntary removal of some 122,000 adults and children of Japanese descent, more than half of them US citizens, who were held in detention centers and eventually concentration camps, where most remained throughout the war years.

McBride's old friend Kunishige and his wife, Gin, were interned along with Dr. Koike, Yukio Morinaga, and other brilliant artists at the Minidoka War Relocation Center near Hunt, Idaho. After their release, the Kunishiges remained in Idaho, where Frank was employed in a Twin Falls photography studio doing commercial work. He held a few small local exhibitions of his earlier artistic photography and regained some recognition, although decidedly minor in comparison to his previous international success. He returned to Seattle by 1950, but at the age of 72, having lost everything and in poor health, he was in no condition to rejoin McBride in her studio. He passed away 10 years later, a sad ending to one of the Northwest's most gifted artists.

After the war, McBride surrounded herself with her extended family: her cousins the Hoerleins and the Bushes. Richard H. Anderson's children also provided her with love and support. She in turn became "Auntie" Ella and was a grandmother figure to the Andersons, taking the boys out to fish, ride horseback, and dig for razor clams (figs. 35, 36).

In 1954 McBride finally decided to retire, on April Fools Day, no less, at the age of 91, but only because of failing eyesight. To compensate for her disability, she learned how to type from recorded lessons. Never one to remain idle, she knit clothing for friends and family members, and remained active with the Soroptimists, depending on close friends such as architect Elizabeth Ayer to drive her to the weekly luncheons at the Olympic Hotel.

In 1962 Seattle held its second World's Fair, called Century 21, which provided the region with renewed national recognition and the towering Space Needle that remains an iconic landmark. McBride had lived to see both of Seattle's important expositions and she anticipated her

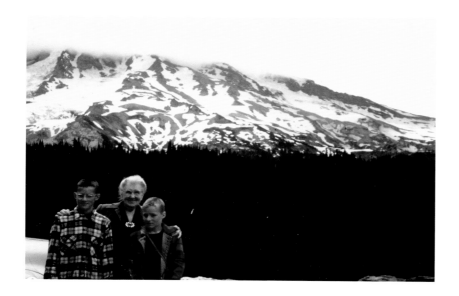

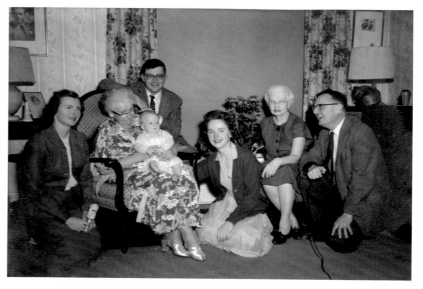

FIG. 35 Ella McBride with Richard Anderson and David McBride Anderson, sons of her business partner, at Mount Rainier, ca. 1950. Photograph by Richard H. Anderson. Courtesy of Richard Anderson

FIG. 36 "Auntie" Ella McBride in her apartment above the McBride and Anderson studio at 133 14th Avenue in Seattle. She is surrounded by family members, from left: Beverlei Hoerlein, Ella holding baby David Hoerlein, Paul Hoerlein, Jody Bush Pitzenberger, housekeeper (name unknown), and Richard H. Anderson. Photograph by Richard H. Anderson. Courtesy of Paul Hoerlein

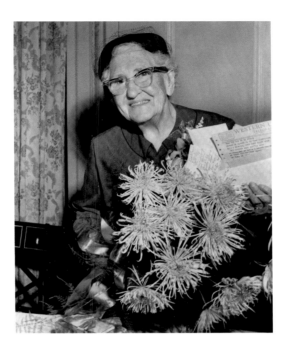

FIG. 37 Press photograph of Ella McBride honoring her 100th birthday, *Seattle Daily Times*, November 15, 1962, page 21. University of Washington Libraries, Special Collections, PH Coll 563 Portraits Collection, UW 38941

100th birthday on November 17 (fig. 37). A local landmark in her own right, she was the subject of several newspaper articles that celebrated her centennial year. When one local reporter asked her to what she attributed her longevity, she responded in a dry, succinct manner: "I was born and I haven't died. I've just kept on."[16]

Still keenly interested in mountain climbing, she kept track of all the important news. In a 1963 interview, she tried to describe the elation of her own mountain-climbing experiences: "You feel like you're Santa Claus and Napoleon Bonaparte and all that, achieving something that no one else ever has, and I think it gives you an uplift and a feeling that ... I can't imagine anything else giving one."[17] That same year, McBride received a visit from local celebrity Jim Whittaker (fig. 38). The legendary Seattle native was the first American to reach the summit of Mount Everest on May 1, 1963. A few months later, he paid a surprise visit to McBride in her nursing home, where they compared notes on mountain climbing from two different centuries. "I don't think I've ever been more thrilled.... My eyesight is failing, and my ears don't function too well but I'm convinced my 'thriller' is still working." Before he left, she admonished him: "Climbing Mt. Everest once is enough. Don't do it again!"[18]

McBride never lost her sense of humor, remaining self-deprecating and sharp until her death on September 14, 1965, just two months short of her 103rd birthday. She had maintained her archive of negatives and records throughout her professional career. These were passed on to her business partner Richard Anderson until their studio closed. For several years, the negatives were stored in a photography studio in Ballard, a suburb of Seattle. When that

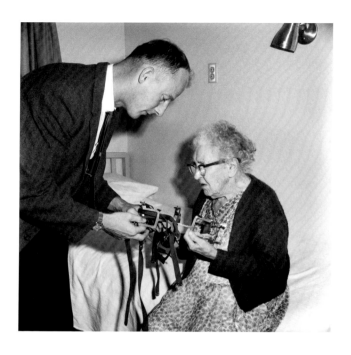

FIG. 38 Mountain climber Jim Whittaker showing crampons to Ella McBride, 1963. Unidentified photographer. Museum of History and Industry, Seattle Post-Intelligencer Collection, 1986.5.44676.2

business folded, McBride's negatives dating from approximately 1915 through the 1960s were deliberately destroyed due to lack of interest from any regional institution with the exception of Seattle's Museum of History and Industry, which accessioned a small but random selection in 1974. The remaining thousands of negatives were incinerated.

NOTES

1 Walter B. Pitkin, *Careers after Forty* (New York and London: Whittlesey House, 1937), 217–18.

2 McBride family history supplied by Paul Hoerlein. Additional information excerpted from Mark Theobald for Coachbuilt.com, http://www.coachbuilt.com/bui/w/wentworth_irwin/wentworth_irwin.htm.

3 Pitkin, *Careers after Forty*, 217–18.

4 David F. Martin, "McBride, Ella E. (1862–1965)," March 3, 2008, HistoryLink.org, http://www.historylink.org/File/8513.

5 Pitkin, *Careers after Forty*, 217–18.

6 Information regarding McBride's activities with Mazamas provided by Sharon Howe, Mazamas archivist, in two separate correspondences with the author on December 18, 2000, and January 8, 2001.

7 Dee Molenaar audio interview with McBride, who was 100 years of age at the time, April 19, 1963. Collection of David F. Martin. The Molenaar interview, which focuses on McBride's mountain-climbing experiences, contains nothing about her photographic career.

8 Edward S. Curtis to Harriet Leitch, July 11, 1949, and November 17, 1950. Harriet Leitch and Edward S. Curtis correspondence, 1949–51, Special Collections, Seattle Room, Seattle Public Library.

9 Pitkin, *Careers after Forty*, 217–18.

10 Information about Josuke Kuniyasu generously provided by curator Yuko Yamaji, Kiyosato Museum of Photographic Arts, Hokuto, Japan.

11 Heister Dean Guie, "A Famous Camera Artist," *Sunset Magazine*, March 1927, 49, 50.

12 Molenaar interview, April 19, 1963.

13 "Honors for Miss McBride," *Town Crier*, May 23, 1925, 6.

14 C. A. Pierman, "Photography as One of the Fine Arts," *Buffalo Arts Journal* 7, no. 2 (May 1925): 25.

15 Dr. Kyo Koike, "Seattle Camera Club," *Camera: The Photographic Journal of America*, September 1926, 130–67.

16 June Anderson Almquist, "Ella McBride, 100 Saturday, Wants Big Party at Age 200," *Seattle Daily Times*, November 15, 1962, 21.

17 Molenaar interview, April 19, 1963.

18 Barney Harvey, "101 in November: Centenarian Honored," *Seattle Daily Times*, August 23, 1963, 7; "Everest Conqueror Visits Former Teacher," *Oregonian*, August 24, 1963, sec. 2, p. 3.

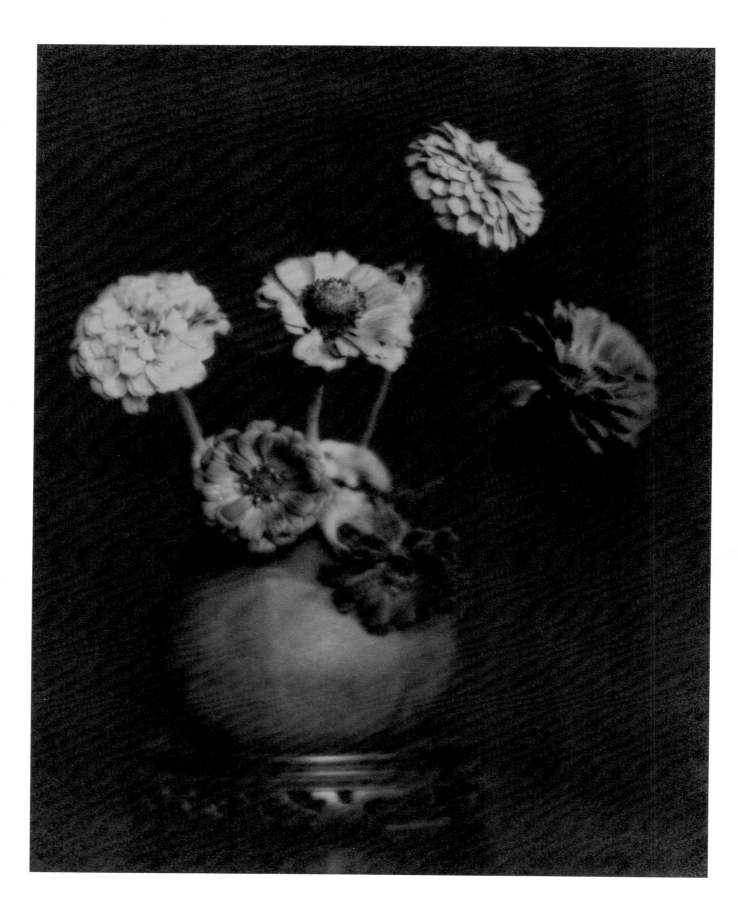

Ella McBride and Pictorial Vision in the Pacific Northwest

MARGARET E. BULLOCK

The images are richly evocative: shadowy streets, hazy vistas, pastoral idylls, poetic portraits, intimate nature studies, scenes from myth or dreams. They are the work of the pictorialist photographers of the Pacific Northwest created in the late 19th and early 20th centuries. Many of these artists had international careers during their lifetime but are little known now, in part as a result of historical events that erased their legacies but also because they were predominantly women or artists of Japanese descent.[1]

One intriguing figure among them was Ella E. McBride (1862–1965), a teacher, a businesswoman, an adventurer, and then by happenstance, an artist. Her life story and the circumstances of her artistic career parallel those of many of her fellow pictorialist photographers, both regionally and internationally. She was self-taught, practiced both commercial and fine-art photography, and participated in an international network of like-minded individuals.[2] She also was an integral figure in Seattle's early photography community. Rediscovering her career not only adds to the growing body of information on the Northwest's photographic history but also sheds light on its relationship to broader national and international artistic developments.

THE EARLY HISTORY OF PHOTOGRAPHY

When photography was invented in the mid-1800s, it was heralded for its scientific and documentary rather than artistic possibilities. This exciting new technology developed and spread rapidly, changing in often startling ways how the world was seen and recorded.[3] Photography's commercial uses were also swiftly recognized and pursued, particularly for advertising and portraiture, and to satisfy the 19th-century public's appetite for landscapes and travel mementos.

Early photographic technologies required bulky equipment, messy chemicals, long exposure times, and immediate processing.[4] The invention of the gelatin dry-plate process in 1871

meant that glass plates (and later celluloid film) could be chemically prepared in advance and printed later, simplifying picture taking and attracting more enthusiasts. George Eastman's introduction of the Kodak camera in 1888 cemented photography's status as a popular pastime available to everyone. The camera was operated with a simple push button, and images were developed and printed by the company so no specialist knowledge was required.

Although the commercial and popular uses of photography were widely accepted, there were many different opinions about the medium's artistic potential.[5] Because photographs were the product of mechanical and chemical processes, many felt there was no avenue for introducing human creativity. The ready adoption of photography for scientific study lent further weight to the argument that it was best suited for documentary purposes. Social politics also played a role. Art in the 19th century was primarily under the purview of the wealthier classes, who believed they possessed more refined sensibilities. They were put off by photography's ready availability and mass appeal, and found its artistic pretensions suspect.[6]

Others, including many artists, recognized some limited artistic potential for photography, but primarily as a tool rather than as a new creative medium. The fact that multiple images could be captured quickly, include significant detail, and be taken from a variety of viewpoints made photography an efficient alternative to preparatory sketches. The black-and-white palette and wide array of possible tonal manipulations also offered new, more complex ways to study light and shadow effects on a composition.

There was, however, a dedicated and passionate contingent who embraced the artistic possibilities of this new technology. They pointed out the affinity between photography and printmaking, a time-honored medium that combined mechanical and chemical means with the creative human eye and hand to make art. To illustrate photography's aesthetic possibilities, they emphasized composition and lighting in setting up their images and advocated that handwork be done on negatives and prints during the developing process to create painterly effects (fig. 1). Photographic societies were established across Europe dedicated to proving the medium's artistic merits, including the Photographic Society of London, established in 1853, and the Société française de photographie, founded the following year. Many societies also published professional journals that made their case to the public, though their exhibitions often muddled the argument by hanging scientific photography, commercial studio portraits, and travel views alongside the artistic images. Art critics were uncertain; the most notable example was the prominent Victorian critic, artist, and tastemaker John Ruskin (1819–1900), who simultaneously embraced and rejected the potentials of photography.[7] Though he took an extensive series of daguerreotypes that he used to inform his artworks and architectural research, he never ventured into trying the camera to create an artistic original.[8]

THE PICTORIALIST MOVEMENT
The broad popular embrace of photography in the late 19th century proved the strongest catalyst for launching a concerted effort to distinguish art photography from other types. In the

FIG. 1 JULIA MARGARET CAMERON (British, 1815–1879), *Whisper of the Muse*, 1865. Platinum print, printed ca. 1915 by Alvin Langdon Coburn from copy negative of original print, 9 ¼ × 8 in. George Eastman Museum, Gift of Alvin Langdon Coburn, 1967.0088.0010

early 1890s, groups began to form specifically to promote camera art. Most were splinter groups from existing photographic societies that wanted to offer their own exhibitions and publications focused solely on fine-art images. One of the first was the Wiener Camera-Klub (Vienna Camera Club), formed in 1891, followed the next year by the Linked Ring Brotherhood, which split off from the Photographic Society of London. The Photo-Club de Paris organized in 1894. Similar groups sprang up all across Europe and Japan, founding an international movement of astonishing reach that came to be known as pictorialism. Members met to exchange ideas, trade images and critiques, and view exhibitions of one another's work. The various societies and clubs also traded exhibitions and publications so that members had access to photographs and discussions about art photography from around the world. The most important venue of exchange was the annual salon.[9] These exhibitions were juried by distinguished art photographers and sympathetic critics from a range of international submissions. Illustrated catalogues and checklists were circulated to those who could not attend in person, and articles on the salons were published in both the art press and the journals of the photography associations. The works chosen for the salons set the standard by which other art photography was judged.

The pictorialists wanted their images to transcend strict realism in order to elevate the everyday and convey an individual vision.[10] They strove to suggest narratives or emotional states and to elicit a personal response in the viewer. One common technique was to create soft images, which they felt lent a poetic atmosphere. The effect was achieved in various ways, from using special lenses or veiling the camera lens to manipulating the image in the darkroom.

FIG. 2 GERTRUDE KÄSEBIER (American, 1852–1934), *Woman Seated under Tree*, ca. 1910. Gum bichromate print, 9½ × 7½ in. George Eastman Museum, Gift of Hermine Turner, 1971.0042.0022

Another key strategy relied on dramatic lighting to create strong contrasts between areas of light and shadow. Other methods to emphasize the artistic intent of pictorialist images included the use of low camera angles, carefully cropped compositions, and deep perspective (fig. 2).

The spread of photography in America and opinions about its uses echoed those in Europe. The figurehead and primary advocate for the art photography movement in the United States was Alfred Stieglitz (1864–1946), who grew intrigued with the medium while studying engineering in Germany. When he returned to the United States in 1890, he joined the Camera Club of New York and became editor of their publication *Camera Notes*. The Camera Club embraced a wide variety of photo enthusiasts and this irritated Stieglitz, who believed strongly in photography's artistic potential. In 1902 he and a handful of others formed their own group called the Photo-Secession. Membership was limited and by invitation from Stieglitz only.[11] Photo-Secession members generally preferred to use darkroom manipulation of negatives and prints to emphasize the artist's active hand in creating photographs. Techniques such as painting on chemicals, scoring with a needle, and scraping were common. Some followed the example of Stieglitz, who used subtle tonal variations, composition, and natural phenomena such as rain or fog to achieve his artistic aims (fig. 3). To further the group's reach, Stieglitz edited and circulated an influential publication, *Camera Work*, that illustrated the work of Photo-Secession members and other artists of interest and included essays on the photographic arts as well as various contemporary art movements. In 1905 Stieglitz opened the Little Galleries of the Photo-Secession in New York, primarily to exhibit the work of member artists.

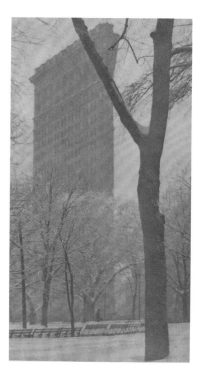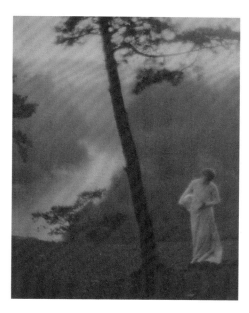

FIG. 3 ALFRED STIEGLITZ (American, 1864–1946), *The Flatiron*, 1903. Photogravure, 12 ⅛ × 6 ⁹⁄₁₆ in. Library of Congress, Prints & Photographs Division, The Alfred Stieglitz Collection, Gift of Georgia O'Keeffe, LC-DIG-ppmsca-19507

FIG. 4 CLARENCE H. WHITE (American, 1871–1925), *Morning*, ca. 1905. Photogravure, 7 ¹⁵⁄₁₆ × 6 ⅛ in. National Gallery of Art, Washington, Robert B. Menschel and the Vital Projects Fund, 2010.76.14

Camera clubs were established all across the United States for the exhibition and encouragement of art photography.[12] One of the earliest and most influential was founded in Buffalo, New York, in 1888. Other active groups included Boston, Chicago, Newark, Philadelphia, Pittsburgh, and San Francisco. These organizations were more welcoming than the Photo-Secession and helped popularize and broaden the definition of art photography in America.

The Photo-Secession disbanded in 1910 as Stieglitz pursued other interests, but one of its members, Clarence H. White (1871–1925), became a less dogmatic but equally influential standard-bearer for pictorialist photography in America.[13] White began taking photographs in the 1890s in the evenings after work. By 1898 he had helped found the Newark Camera Club, was regularly exhibiting his photographs, and had formed an international network of friendships with other pictorialist photographers, including Stieglitz, who invited him to join the Photo-Secession as a founding member (fig. 4). White's philosophical roots were grounded in the Arts and Crafts tradition of finding beauty in the everyday, and he believed that artistic principles could be applied to all varieties of photographic work.[14] In 1914 he opened the Clarence H. White School of Photography in New York City, the only US institution devoted to teaching art photography. His program emphasized design and the pursuit of photography as a career. In 1916 White and two other former Photo-Secession members, Gertrude Käsebier (1852–1934) and Alvin Langdon Coburn (1882–1966), founded the Pictorial Photographers of America (PPA), an organization that aspired to shape the public taste for photography in addition to advancing the art form.

White did not preach a particular set of aesthetic strategies for art photography but instead supported and encouraged his students' photographic experiments. He also welcomed the growing range of creative imagery that was appearing under the pictorialist label in the national and international photography community. Over time, the work of White's students and those who exhibited with the PPA began to display the influence of various modernist art movements, including impressionism, symbolism, surrealism, cubism, and expressionism as well as the opposite pole of "straight" photography. It was once again Stieglitz who began championing this other mode of photography after he turned from pictorialism in 1910. The artists relied entirely on what was seen through the camera lens, using no enhancing effects, cropping, or darkroom manipulations to create an image. By the late 1910s pictorialism had come to be defined by its underlying philosophy—that photography was a medium for artistic expression—rather than by a specific look or set of techniques.

The Associated Camera Clubs of America (ACCA), composed of 22 charter members, was formed in 1919. It formalized and facilitated exhibition exchanges among clubs in the Northeast and Midwest and on the Pacific Coast. To encourage the formation of other camera clubs nationwide, in 1922 the ACCA issued *The Camera Club: Its Organization and Management*, a pamphlet describing in detail how to establish and run such an organization. The Eastman Kodak Company followed with its own publication soon thereafter. The number of camera clubs nationwide continued to grow rapidly through the 1920s and even through the Great Depression, thanks in part to the classes, facilities, and exhibitions sponsored by the Federal Art Project of the Works Progress Administration.

EARLY PHOTOGRAPHY IN THE PACIFIC NORTHWEST

Photographers followed settlers and the gold rush into the West in the early 1850s. Portraitists set up studios in boomtowns such as Portland, Salem, Tacoma, Seattle, and Spokane to capitalize on the desires of their rootless populations to send images home. Like other artists, photographers were drawn to the Northwest by stories of its unparalleled wild landscapes. The railroads also frequently hired them to take images along their routes to promote tourism. Artists such as Carleton Watkins (1829–1916) took some of the earliest photographs of the spectacular Northwest landscape. Watkins traveled throughout the region with his portable photo studio, capturing stunning images despite the challenges of developing and printing in the field (fig. 5). Other photographers created businesses that specialized in documenting the rapid changes happening in the West. One such couple was Darius (1869–1945) and Tabitha (1875–1963) Kinsey, who were based in northwest Washington State. They took thousands of images of the lumber industry, railroads and ports, people and landscapes of the region starting in the 1890s, providing an invaluable photographic resource on early industries and Euro-American settlements in the Northwest (fig. 6).[15]

Camera clubs were popular in the region, offering a place where photo enthusiasts could gather, socialize, and exchange and exhibit work. The Oregon Camera Club, organized in Portland in winter 1894–95, was one of the earliest. A similar group was formed in 1895 in

FIG. 5 CARLETON E.
WATKINS (American, 1829–
1916), *Cape Horn, Columbia
River, Oregon*, 1867. Albumen
print from collodion negative
mounted on paperboard,
19 ¾ × 15 in. National Gallery
of Art, Washington, Patrons'
Permanent Fund, 1995.36.126

FIG. 6 DARIUS KINSEY
(American, 1869–1945),
*Camp #3, Weyerhaeuser
Timber Co.*, date unknown.
Gelatin silver print, 11 × 14 in.
Tacoma Art Museum, Gift of
David F. Martin and Dominic
A. Zambito, 2010.15.1

Seattle. The Photographers Association of the Pacific Northwest, an umbrella organization for camera groups throughout the region, began holding exhibitions in 1900.[16]

The debate over the artistic potential of photography traveled west along with the technology, and a strong pictorialist group emerged in the Northwest in the 1890s and early 1900s. In Oregon three photographers, Sarah Hall Ladd (1857–1927), Lily Edith White (1866–1944), and Myra Albert Wiggins (1869–1956), were the most notable participants.[17] Ladd and White were both primarily interested in photographing the Northwest landscape (fig. 7). Wiggins became interested in photography while studying painting at the Art Students League in New York City. Her pictorial images included landscapes but she had a particular interest in genre scenes and vignettes re-created from Dutch period pictures (fig. 8). She later relocated to Seattle and became a key figure in the Washington photography community. Ladd and White became nonresident members of the Camera Club of New York, and all three women were later invited by Stieglitz to join the Photo-Secession as associate members.[18]

Two other artists of particular note among the Oregon pictorialists were Henry Berger Jr. (1877–1939) and Fred Yutaka Ogasawara (1883–death date unknown). Berger was active in Portland from 1900 to 1915 as a member of the Oregon Camera Club and eventually opened a professional photography studio. He also participated in numerous national and international pictorialist salons (fig. 9).[19] Ogasawara became involved with photography in Seattle and then relocated to Portland, where he forged a successful and international career during the 1920s. He returned to Japan just before the outbreak of World War II and few of his images and little information about him are currently known (fig. 10).[20]

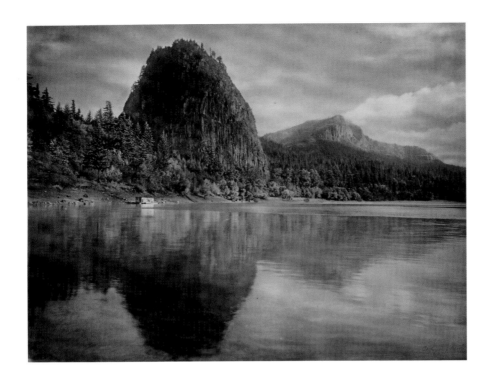

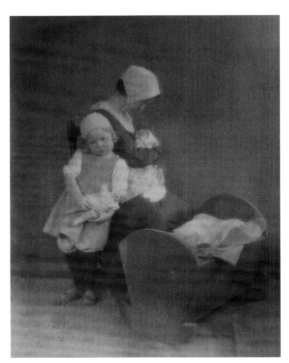

FIG. 7 LILY E. WHITE (American, 1866–1944), *Castle Rock, Columbia*, 1902/1904. Platinum print, 10 ⅛ × 12 ¹¹⁄₁₆ in. Portland Art Museum, Portland, Oregon, Museum Purchase: Portland Art Museum Volunteer Art Council and Ann Swindells in honor of Joyce Anicker, 1997.2.3

FIG. 8 MYRA ALBERT WIGGINS (American, 1869–1956), *Dethroned*, ca. 1921. Silver chloride print, 8 ½ × 6 ¼ in. Tacoma Art Museum, Gift of David F. Martin and Dominic A. Zambito, 2009.15.11

FIG. 9 HENRY BERGER JR.
(American, 1877–1939),
Untitled (Archway with Iron
Gate), ca. 1915. Gelatin silver
print, 18 × 13¼ in. Portland
Art Museum, Portland,
Oregon, Gift of Abraham
Kupersmith, 2002.81.67

FIG. 10 FRED YUTAKA
OGASAWARA (Japanese,
1883–death date unknown),
The Aged Fence, ca. 1921.
Gelatin silver print,
4½ × 5⅝ in. University
of Washington Libraries,
Special Collections
Division, Matsushita Family
Photograph Collection,
UW 29087z

Photography in the Portland area was further encouraged by public exhibitions. Anna B. Crocker, the first curator at the Portland Art Museum, regularly scheduled exhibitions of art photography, including from local collections. The sprawling art exhibition at the Lewis and Clark Centennial Exposition in 1905 included a group of works by Photo-Secession members.[21]

In Washington State, Seattle attracted a host of photographers. Many of the commercial portrait studios that opened in the late 1800s and early 1900s belonged to immigrants from Japan and China.[22] The best known of the early pictorialist photographers to settle in the area was Edward Sheriff Curtis (1868–1952), who opened his first studio in Seattle in 1891. His reputation increased in tandem with his growing interest in pictorialism, driven by the artistic elements he incorporated into his images (fig. 11). The studio also became an important training ground and connecting point for a number of Washington photographers, most notable among them a young Imogen Cunningham (1883–1976), who worked in the Curtis darkroom from 1907 to 1909. Curtis's images for *The North American Indian* (1907–30), his massive project to document every government-recognized Native American group in the United States, drew heavily upon pictorialist strategies to carry Curtis's overarching theme that these were the last images of vanishing cultures. The heavy shadows, soft toning, and generally static compositions were designed to evoke nostalgia and gentle melancholy over the fate of his subjects.[23]

Adelaide Hanscom (1876–1931) moved to Seattle after the 1906 San Francisco earthquake and fire destroyed her studio. She had an established reputation as a pictorialist photographer who specialized in images meant to re-create or evoke scenes from literature, history, and myth. Her images for a 1905 edition of *The Rubáiyát* by poet Omar Khayyám (1048–1131) are

FIG. 11 EDWARD S. CURTIS (American, 1868–1952), *Bird Rookery off of Hall Island, Bering Sea, Alaska, July 1899*, 1899. Gelatin silver print, 4 × 5 in. University of Washington Libraries, Special Collections Division, Harriman Alaska Expedition Photograph Album Collection, Harriman 181

FIG. 12 ADELAIDE HANSCOM (American, 1876–1931), illustration from *The Rubáiyát of Omar Khayyám*, trans. Edward Fitzgerald, ca. 1905. Photogravure on tissue, 6¼ × 4⅝ in. Tacoma Art Museum, Museum purchase with funds from the Amanda Snyder Fund, 2015.5.3

considered the first photographic illustrations of a literary text (fig. 12). Though Hanscom spent only a few years in Seattle before returning to California, several other Washington photographers later followed her lead, creating theatrical "illustrations" of well-known texts.

One of the most significant developments in the history of pictorial photography in Washington was the arrival of two Japanese artists in the 1910s, part of a wave of Japanese immigration to the Pacific Northwest in the early 1900s. Dr. Kyo Koike (1878–1947) came to Seattle from Shimane Prefecture in late 1916. A physician and surgeon, he also was a poet, an editor, and a naturalist and had begun taking photographs in Japan (fig. 13). Koike and other photography enthusiasts in Seattle's Japanese community began to gather after work to share and discuss their images and encourage one another's efforts. In 1924 they decided to formally organize as the Seattle Camera Club (SCC). The 39 original members were all of Japanese descent, though the club was open to anyone interested in art photography.[24] Among them was Frank Asakichi Kunishige (1878–1960), another photographer who would have an important impact on pictorialist photography in the region. Kunishige was one of the few professionally trained photographers in the group. He immigrated to the United States in 1896 and trained at the Illinois College of Photography from 1911 to 1913. After running a studio in San Francisco for several years, he moved to Seattle in 1917 to work for Curtis. There he met McBride, whom he began working with in 1919 and who became a lifelong friend and colleague.

There were a variety of public opportunities to view pictorialist photography in Seattle in the early decades of the 1900s. The art exhibition of the 1909 Alaska-Yukon-Pacific Exposition featured a large group of international pictorialists, including several prominent members of the

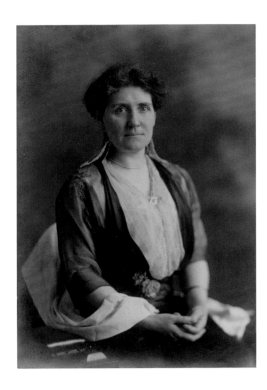

FIG. 14 Ella McBride, ca. 1915.
Unidentified photographer.
University of Washington
Libraries, Special Collections
Division, Janet Anderson
Collection, UW 38939

Photo-Secession. The Washington State Art Association began sponsoring photography exhibitions in downtown galleries in 1912. Although the first exhibition consisted primarily of commercial works, the second had more than 100 artistic photographs by Curtis, Wiggins, and other regional photographers.[25] Other local organizations also occasionally sponsored exhibitions of art photography. In 1920 the Frederick & Nelson department store in downtown Seattle began hosting pictorial photography salons. They were ambitious and comprehensive, with the first encompassing more than 500 works.[26]

The Northwest's enthusiastic embrace of photography of all kinds opened up opportunities for commercial and artistic practitioners alike to flourish and for many to combine both approaches in their careers. A number of photographers supported themselves through commercial and portrait studio work while creating their fine-art images outside of business hours. Community support and enthusiasm for artistic imagery fostered an environment that was particularly hospitable to a varied and richly creative group of pictorialist photographers.

MCBRIDE'S CAREER IN PHOTOGRAPHY

McBride joined the Seattle photography community in 1907 at the invitation of Curtis (fig. 14). She left behind a career as a teacher and school principal in Portland to embark upon a new life adventure.[27] McBride was an avid outdoorswoman who loved hiking and mountain climbing. In Portland she was a member of the local mountaineers club, Mazamas, and amassed an impressive list of more than 37 major climbs. In an encounter worthy of a Hollywood movie script, McBride met Curtis on the slopes of Mount Rainier in 1897. He was

impressed with her character and spirit. They became friends and went on other climbing expeditions together. Once Curtis began to fully dedicate his energies to his *North American Indian* project, he spent increasingly less time overseeing his Seattle studio. In 1907 he persuaded McBride to bring her steady head and professional talents to Seattle to run the studio while he traveled.[28]

McBride, who had no background or training in photography, ran the business side of the studio. Among the team when she arrived was Adolph F. Muhr (1860–1913), Curtis's longtime printer who ran the darkroom, assisted by Cunningham. McBride worked for Curtis for nearly a decade, becoming close friends with his family. Curtis's increasing absences and financial struggles made it a challenge to keep the studio going; McBride and Curtis's daughter Beth tried unsuccessfully to buy the business from him. McBride decided in 1915 to open her own photography studio. Edmund Schwinke (1888–1977), who had been one of Curtis's photographers for many years, had also reached his breaking point with Curtis and became an absentee partner in the McBride Studio until 1922.

From the start, the studio attracted a variety of talented photographers. Two key figures arrived in 1918: Wayne Albee (1882–1937) and Soichi Sunami (1885–1971). Albee had relocated to Seattle the year before from Tacoma, where he had been pursuing a career in both studio and fine-art photography.[29] He was an active member of the Photographers Association of the Pacific Northwest who consistently won awards for his pictorialist images and had a prize-winning work illustrated in *Camera Work*, the selective publication of the Photo-Secession. He became a partner in the studio and its chief photographer.

Sunami arrived in Seattle in 1907.[30] He originally trained as a painter and was an active member of the Seattle Art Club, exhibiting paintings and sculpture. It is unclear when he became interested in photography, but he had sufficient experience by 1918 to be hired to work at the McBride Studio. It was during the four years he worked there that he began to fully pursue fine-art photography, which he found a more congenial medium than painting. In 1919 Kunishige left the Curtis studio and came to work for McBride as well.

It was in working closely with Albee, Kunishige, and Sunami that McBride became interested in trying fine-art photography herself around 1920 and was able to master her new passion so quickly. She began exhibiting her work almost immediately and became internationally known with astonishing speed. The first documented public display of her photographs was a 1921 exhibition of pictorial images sponsored by the *North American Times*, a Japanese newspaper in Seattle. The following year her work was selected from thousands of international entries for a competition sponsored by the Royal Photographic Society of Great Britain. Three of her works were included among the twelve selected to represent American pictorialism. In a survey published by the *American Annual of Photography* in 1927, she was listed as one of the top 10 most-exhibited pictorialist photographers in the world during 1925 and 1926 and was the only woman among them (fig. 15). Her exhibition history, the full scope of which is detailed in David Martin's essay in this book, reveals an artist who mastered both the technical and the artistic aspects of the medium almost overnight, creating a large body of high-quality work in the span of just a decade.

FIG. 15 Exhibition labels from the Seventh International Salon of Pictorial Photography, Los Angeles, 1923, and the International Art Photography Exhibition, Budapest, 1927, affixed to the verso of McBride's photograph *The Broken Bowl*, ca. 1922. Private collection

Another important factor in McBride's wholehearted and skilled embrace of pictorialist photography was her membership in the Seattle Camera Club. The SCC offered a broad network of exchange for ideas and techniques. At their meetings she could see and discuss the work of others and hear critiques of her own images. The SCC was an ambitious and active organization. In addition to mounting exhibitions of the members' work, it also began organizing an annual salon of pictorial photography in 1925. The first included 34 photographers mostly from the region; by the third, it included works by 162 photographers from 20 countries.[31] The SCC was a member of the Associated Camera Clubs of America and hosted a number of their traveling exhibitions. Publications offered a further resource, containing how-to articles, essays, and critiques, and illustrating work from around the world.

The momentum of McBride's artistic career was halted rather abruptly by the Great Depression. A solo exhibition of her work at the Art Institute of Seattle in 1931 was one of her last. The SCC disbanded in 1929 as members were no longer able to afford materials or ship their works to exhibitions. McBride was forced to concentrate her efforts on making a living through her commercial studio and ceased pursuing her artistic career, though she remained involved in the photography community.

INFLUENCES ON MCBRIDE'S WORK

When McBride died in 1965 at the age of 102, she had no siblings or children to care for her legacy and thousands of negatives and photographs were eventually destroyed; approximately 150 prints are known today. No writings by or about McBride exist to elucidate what drew her

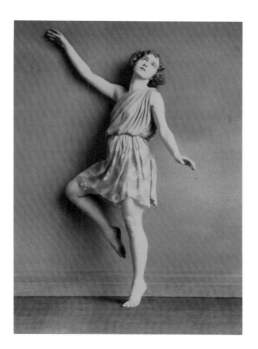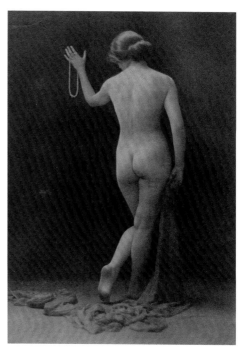

FIG. 16 WAYNE ALBEE
(American, 1882–1937),
*Portrait of the Dancer
Evangeline Edwards*, ca. 1922.
Tinted silver print, 6 ¼ ×
4 ⅜ in. Tacoma Art Museum,
Gift of David F. Martin
and Dominic A. Zambito,
2009.15.10

FIG. 17 FRANK ASAKICHI
KUNISHIGE (Japanese,
1878–1960), *Pearl Necklace*,
ca. 1920. Vintage chloride
print on Japanese paper,
8 ⅞ × 6 in. Tacoma Art
Museum, Museum purchase
with funds from a gift of
Jared FitzGerald, 2011.19.3

to photography or what she hoped to achieve in her work. In one of the few surviving quotes she noted, "I went into pictorial photography and my avocation and vocation were one."[32] And in an interview late in life she credited Albee with encouraging her to pursue her interest in the medium.[33] Beyond those tantalizing tidbits, it is through looking at her career in the context of pictorialism and in relation to her friends and associates, and by analysis of her works themselves that answers to some of these questions can be suggested.

McBride, like most early photographers, was self-taught, learning through hands-on experimentation, watching others at work, reading, and looking at other artists' photographs. She had the added advantage of owning a fully equipped studio staffed by talented and creative photographers with distinctive individual voices who encouraged and assisted her. Albee was particularly interested in figurative work. His portraits are sensitive and striking, conveying the personality of his sitters, including some of the greatest early modern dancers.[34] The resulting images are a blend of portrait and performance, suggesting both the role and the artist inhabiting it (fig. 16). Kunishige was a technical master of highlights and toning. Precisely placed gleams of light and subtle variations in shades of gray lent his works visual sensuality and richness, enhancing the mysterious or dreamy, erotic air common to his images (fig. 17). Sunami brought drama and movement as well as a modernist sensibility to his images. He emphasized the gestures of his figures and the shapes of their bodies in space rather than details or personalities. In both his landscapes and his figurative works, he accentuated contrasts between light and dark masses. He frequently also used soft focus to further blur distinctive characteristics, often to the point of abstraction (fig. 18).

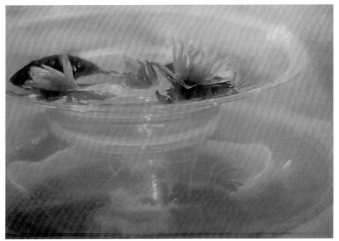

Japanese aesthetics had an impact on McBride's style, perhaps most notable in her interest in flower studies, a subject none of her close associates pursued. As noted above, several of McBride's close colleagues were of Japanese descent as were the majority of the members of the Seattle Camera Club. The SCC's monthly bulletin *Notan*, edited by Koike, was published in English and Japanese and included Japanese art, poetry, and literature alongside photographs by SCC members. In an article for *American Photography* in 1928, Koike discussed the influence of Japanese woodblock prints on the compositions of most of the works by Japanese photographers, the art of the tea ceremony on their still lifes, and the principles of ikebana on their landscape and flower images.[35] Scholars of Asian American art also have noted that time-honored Japanese subjects such as landscapes and flower arranging were aesthetic traditions that artists brought to their work in America along with a visual vocabulary that emphasized pattern, asymmetry, flattened space, and unusual perspectives.[36]

American pictorialism was tightly interwoven with the movement in Europe, and through constant exchanges of exhibitions and publications European pictorialist images would have been another consistent influence on McBride. Without specific references from her it is difficult to point to any one influence, except perhaps the enigmatic photographer Adolf de Meyer (1868–1946), who had a particular interest in still-life and floral imagery (fig. 19).[37] He believed that the control of light was key to creating an expressive image, either while taking the photograph or in the developing and printing process.[38] At times a distinct surrealist element also crept into his work. Furthermore, de Meyer served as the principal photographer for the Ballets Russes and so shared a number of subjects and interests with McBride, as will be discussed

FIG. 18 SOICHI SUNAMI
(Japanese, 1885–1971),
October Mist, ca. 1920.
Gelatin silver print,
9 × 6 ¾ in. Collection of the
Soichi Sunami Estate

FIG. 19 ADOLF DE MEYER
(French, 1868–1946), *Water
Lilies*, ca. 1906, printed 1912.
Platinum print, 10 ¼ × 13 ⅞ in.
Metropolitan Museum of Art,
New York, Alfred Stieglitz
Collection, 1933, 33.43.234

below. As a prominent pictorialist she would have seen a variety of his images, and a number of her compositions and ways in which she used light are reminiscent of de Meyer's work.

As noted previously, by the 1920s, when McBride was creating her own works, pictorialism had come to embrace a wide variety of techniques, subjects, and compositions. New ideas were drawn from modernist sources, and straight photography was also beginning to have a following. Other regional photographers, including fellow SCC member Virna Haffer (1899–1974), were pursuing a number of experiments along these lines, which McBride would have seen at club meetings or exhibitions. By the time she took up pictorialist photography, she had a broad range of ideas and techniques from which to build her own distinctive style.

MCBRIDE'S PHOTOGRAPHS

The surviving body of images by McBride consists predominantly of floral studies, but she also created landscapes, figural images, and still lifes. There are variations by subject but common stylistic characteristics include the use of pinpoint focus and precisely placed highlights for emphasis, experiments with spatial compression, and cropping as a compositional technique. Her technical mastery is evident throughout her images, particularly in the subtle toning she achieved, a skill she most likely refined through observing Kunishige at work and also possibly through her time at the Curtis studio with Muhr, a photographer renowned for his carefully modulated photographic prints. McBride also regularly used a thin printing-out paper made by Kunishige, called Textura tissue, to add texture and enhance tonal depth.

McBride's signature subject was floral studies. They were her most award-winning and most frequently exhibited images, and their range and quality confirm her extraordinary technical abilities as well as her refined creative vision. Floral still lifes were not a common choice for pictorialist photographers, most likely because they seemed too close to the documentary images of botanists and other natural scientists from which fine-art photographers were keen to distance themselves. One pictorialist photographer who did explore the subject in depth was de Meyer, noted previously as a possible influence on McBride's work. The number and variety of floral images by McBride make stylistic discussion daunting, but there are four recurring qualities that can be traced through these images that offer insights into her aesthetic interests.

A distinctive characteristic that elevates her flower studies above the average is the sense of presence that emanates from many of them. They go beyond descriptive appreciation of detail to an encounter with the essence of a unique living being. One of the most evocative is her image of the leaf of an elephant ear plant (ca. 1922; plate 23). It is a photograph of three rather homely leaves in a water-filled glass beaker against a background of rough cloth and yet it radiates personality. McBride carefully modulated shades of gray and black across the surface of the large leaf that dominates the composition so that every detail of its crinkly surface can be appreciated. In contrast, the smaller leaf at left is richly, darkly toned. The simplicity of the setting and lack of depth also concentrate attention on the plant itself. Here McBride demonstrates another of her signature techniques, using pinpoint focus to create small areas of intense depth that emphasize the dimensionality of her subject. She uses this strategy on the

smallest leaf, just visible at center, setting up a collision between its reach into space and the flatness of the background that adds a surreal element to the photograph, another common quality of her work discussed below.

There are numerous other stellar examples in which McBride seeks to capture the particular presences of her floral subjects in various ways. In *Zinnias* (ca. 1921; plate 12), light and focus are concentrated on the distinctively individual flower heads. The background, ceramic jar, and even the flowers' stems fade back so that the blossoms seem to float free in space, reaching and turning into the light. Though petals, pistils, and stamens can be read in detail, McBride's treatment leads to deep contemplation of their essence rather than their physical characteristics. Her *Portrait of a Tulip* (ca. 1924; plate 37) is yet another variation on this theme. The only emphasis in the bottom two-thirds of the image is the highlight that accents the gentle curving gesture of the blossom's long fragile stem. Visual interest is centered on the flower at the top edge, where the masterful use of long depth of field offers a journey into the unique miniature world at the heart of the flower.

Drama is another quality inherent in a number of McBride's floral images and one shared by many of her fellow pictorialists. It is created primarily with shadows and bold shapes. In *Dogwood* (ca. 1921; plate 9), the asymmetrical composition and expressive upward curve of the flowering branch are further heightened by the distinctive shadows cast on the backdrop. The open blossom at center is spotlit, a theatrical pop of white against dark leaves. McBride selectively maximizes focus to further differentiate individual flowers from their shadowy background. Her image of daffodils (1921; plate 3) is distilled to light and dark, and the regal postures of the flowers and their silhouettes. The opposite dramatic effect is achieved in her photograph of a black ceramic vase overflowing with pale, frilly miniature roses, every fold and ruffled petal bathed in light (ca. 1921; plate 5).

As noted previously, certain of McBride's compositions have surrealist qualities. Her award-winning image *The Magic Vase* (ca. 1924; plate 36) uses deliberate distortion. The tiny vase is dwarfed by the tulip's large leaves and impossibly long, slender, curving stem that seems too fragile to support the full blossom at its head. Another example is a photograph of three narcissus flowers in a vase with a ceramic snake coiled around its neck (ca. 1924; plate 38). McBride disorients the viewer by compressing foreground and background, creating tension between the dimensional roundness of the vase and the flat backdrop. Flowers and vase stand out so sharply that they seem to be emerging from the wall behind. *From a Kitchen Garden* (1925; plate 42) evokes an image out of a dream. Background and table merge into a soft indistinct mass. The knobby heads of the allium flowers, dramatically lit and focused, emerge sharply from a haze of feathery fronds and the shadowy container of water that holds them. The off-center composition and tension between elements are disorienting and vaguely disturbing.

Finally, McBride's works demonstrate an ongoing interest in abstraction, a quality drawn from modernist aesthetics. It is most often expressed in her work through pattern, texture, and spatial compression. Her *Eryngium—An Arrangement* (ca. 1924; plate 34) is a study of the spiky blossoms and twigs of the floral spray. Focus is soft throughout so individual details are blurred,

but shapes and lines are emphasized. Tiny highlights accent bits of petal and stem throughout, further adding to the visual texture of the image. The overall impression is of the physical gesture of the flowering branch in space. In *Chinese Water Plant* (ca. 1922; plate 14), McBride uses toning and soft focus to abstract the plant to the shapes of its stems and leaves. The dark wood sill and side of the shallow niche that frames vase and plant blur into the plain light background, creating a quiet echo of the contrast between black and white in the foreground. The extreme close-up of *Eastertide* (ca. 1922; plate 15) forces attention on the star shape formed by the petals. Details at the center are softened away so that only the shapes of the fuzzy black dots of the anthers and the bumpy irregular form of the stigma are emphasized.

The most awarded, exhibited, and illustrated of McBride's images was her photograph titled *A Shirley Poppy* (1925; plate 43). It marries all of the characteristic qualities and technical flair seen in other works in a single image that distills the delicacy and uniqueness of the flower into a poetic meditation. The combination of traditional pictorialist and modernist aesthetics seen here was the predominant form of pictorialism in the 1920s when McBride created this work and was likely part of its appeal. But the uncommon subject matter, her technical mastery, and her distinctive approach were the primary reasons it became her signature image.

Related to McBride's florals are her still lifes. These are studio arrangements, often of Chinese objects that were given to her by a man named Goon Dip, who had used them in a display at the Alaska-Yukon-Pacific Exposition in Seattle in 1909 (plates 28, 46).[39] McBride had met Goon Dip in Portland; he later became a successful businessman in Seattle and Chinese Consul to Washington State. They were lifelong friends and she had close ties to his family.[40] For McBride still lifes seem to have served as an opportunity not only to experiment with the complexities of light and focus but also to accentuate the beauty of the everyday, a key tenet of pictorialism.

Old Chinese Wine Jar (ca. 1922; plate 19) is one such meditation. McBride carefully accented the elaborately carved design on the sides of the jar, which is echoed in the cluster of real leaves and floral sprigs on the quietly gleaming tabletop. Subtle variations in toning and tiny highlights emphasize the three-dimensionality of the jar's spout and the ornament on the lid, and that of the leaves in the left foreground whose every detail is clearly defined. The same wine jar appears in an atmospheric still life alongside a goldfish bowl (ca. 1922; plate 24). The photograph is a dramatic study in dark and light, from the deep black background and gleaming objects to the eerie shadows of the fish reflected in the translucent sides of the bowl. It exudes an air of antiquity and mystery, suggesting some elusive story.

A rare pair of photographs of the same simple still life of a silver pitcher and a bowl of cherries illustrates the kinds of stylistic variations McBride used to achieve different effects. Exhibition labels on the backs of the photographs confirm that she exhibited both equally. In one image, light floods in from the right side, washing out detail in the center of the bowl of cherries and on the side of the pitcher (1925; plate 44). The strong illumination also creates distinct curving shadows on the backdrop and picks out the sinuous curve of the pitcher's handle. It is a dramatic image emphasizing shapes, masses, and dark and light. The other version reads more as a meditation on beauty (ca. 1925; plate 45). The light is softer and more evenly distributed; the

backdrop is covered with a lacy, shadowy pattern. Gentle highlights on the body of the pitcher accent its rounded curves and polished surface. The handle, neck, and lid stand out sharply against a black shadow, enhancing the pitcher's dimensionality and elegant outlines.

McBride's landscapes are her most traditional compositions and make use of time-honored artistic tropes from painting. In *Midsummer* (ca. 1925; plate 48), for example, framing elements in the foreground define the main area of interest and atmospheric perspective creates the illusion of depth. True to her interest in flowers, a number of McBride's landscapes are garden studies, but she seems to have been interested more in the overall texture and pattern of the masses of flowers she depicted than in recording a particular place (plate 27). Space is often flattened and the image cropped to screen out other parts of the surrounding landscape, creating an abstract mass of shapes across her composition (plate 30).

One of her few cityscapes, *The Cathedral Steps* (ca. 1924; plate 32), is an intriguing hybrid of pictorialist moodiness and modernist abstraction. The tight cropping of the image emphasizes the interlocking geometric shapes of the architectural forms. The ambient light at the moment McBride chose to take the photograph creates a play of light and shadow across the stone surfaces. Much of the only surviving print of this image is silvered, but the original toning is still present in the center. It is soft and warm with minimal modulation, suspended in a timeless haze.

It is unclear whether the relatively small number of landscapes and cityscapes by McBride is simply an artifact of which images survived or an indication that she didn't find them of abiding interest. Her other works reveal her careful command of every detail, so it is possible that the lack of control over lighting and other conditions outdoors made these subjects less appealing.

McBride's figurative images range from straightforward portraits to narrative scenes. Her studio portraits are designed to capture the essence of her subjects and all other elements are subjugated to that purpose. Generally her sitters wear dark or neutral clothing with some form of white or light framing element below the face, such as collars and necklaces (plate 56). Their poses are neutral, props are rare, and the backgrounds are minimal. Emphasis is concentrated on the sitter's face. Here McBride's mastery of toning is clearly evident. Light plays subtly over the surface of skin and captures fine details of expression around the eyes and mouth, as in one of her portraits of Kunishige (ca. 1922; plate 16). Her personal connection to many of her subjects is evident in the care she lavishes on these distillations of their character. Myriad small elements reveal her technical finesse. In *Reverie* (ca. 1925; plate 49), for example, an image of fellow artist Yasuda Ryumon (1891–1965), McBride has emphasized the darkness of his hair, captured tiny highlights on the rim of his glasses, and sharpened the focus on his pipe. All of this serves to concentrate the viewer's attention on Ryumon's face, even though the picture is a half-length portrait and the background is covered with an eye-catching pattern.

Within this body of portraits are a few images of a type popular among pictorialists: lovely young women who were felt to embody the essence of femininity. McBride followed tradition in presenting these sitters in profile with downcast eyes, gently lit, and softly focused throughout (plates 6, 39). Another image that could be described as a portrait of a type rather than an

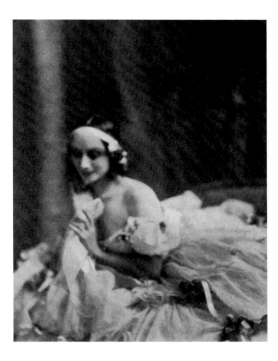

FIG. 20 ELLA E. MCBRIDE, *The Incomparable* (portrait of Anna Pavlova), ca. 1924. Published in the *American Annual of Photography* (1927), page 123

individual is her photograph of an unidentified artist at work (ca. 1922; plate 26). The painter is deliberately turned away, revealing only the back of his head. The image is tightly cropped and flattened, and the artist's body and paintbrush blend with the shadowy figures on the wall, making him one with his work. McBride emphasizes the act of creation by flooding the artist's outstretched arm and touching his head with light. It is a technical and creative tour de force. The variety of subtle changes in tone, light, and focus on the figure's hand, head, and collar intensify the moment of inspiration she is depicting.

Starting in 1915 and for the next several decades, the McBride Studio was hired by the Cornish School of Allied Arts (now the Cornish College of the Arts) in Seattle to take advertising images and document performances by visiting and local artists, particularly the dancers, many of whom were internationally known. As promotional images, they are portraits of the dancers' roles rather than individual portraits in the traditional sense. One of the most exquisite and evocative is McBride's image of Adolph Bolm, a principal dancer with the Ballets Russes (ca. 1922–24; plate 41). His pose contains both grace and abandon. The highlights on his knees, arm, and bracelet are sensual and rich. And though there is an overall softness to the image enhanced by the tissue on which it is printed, every detail of expression and costume can be traced. McBride's portrait of the prima ballerina Anna Pavlova is a fantasy, with the dancer's soft shoulders and gleaming hair rising disembodied from an abstract sea of tulle touched and textured with light (ca. 1924; fig. 20).

Compositions that suggested narratives or illustrated scenes from literary works were popular with pictorialist photographers. The setting and props, the figure's pose, and the image's title

all were used to convey the storyline. McBride created a number of such images. In her allegorical depiction of *Cain* (1921; plate 1), the firstborn son of Adam and Eve has no visible flaws, and the play of light and soft focus emphasizes his physical beauty. But he is surrounded by formless space, his body blending into the darkness, and his pose, with one arm curved over his bent head, is reminiscent of countless images of Adam and Eve being expelled from the Garden of Eden, his sin echoing from theirs. It is the most literally painterly of McBride's images, as close inspection reveals that during printing she brushed on developer around the torso to erase the boundary between figure and ground. *Judging a Print* (ca. 1926; plate 51) is a work that contains a personal narrative. The two models are McBride's assistant Kunishige (in the visor) and the artist Ryumon, who was depicted in *Reverie*. The emphasis, however, is on the tools of the photographic trade. McBride has selectively sharpened the focus and brightened the light on the workaday developing trays on the counter and on the scales and bottles on the shelf above, treating them as precious objects. The image encapsulates and celebrates an everyday moment in the new profession she had joyfully embraced.

CODA

Ella McBride's career as a pictorialist photographer was short-lived, but in that roughly 10-year span she created a body of work that is stunning in its scope, quality, and technical command. Although it is understandable to regret all the work that was lost after her death, that loss should not overshadow what exists. Her photographs speak of her creative talent, her deep appreciation of beauty, her adventurous and curious spirit. They also evoke the community of artists of which she was a part who gathered around a shared aesthetic vision and furthered the evolution of a new artistic medium. One of the stubborn myths about the western edge of America is that its young cities and rural communities were isolated and uncultured, lagging far behind cultural developments in other parts of the country and the world. What the stories and works of artists such as McBride and her fellow photographers conversely prove is that those barriers are in our histories not their experiences.

NOTES

1 In the last few decades, regional scholars have begun to rediscover these histories. Key sources
include Robert D. Monroe, "Light and Shade: Pictorial Photography in Seattle, 1920–1940, and the
Seattle Camera Club," in *Turning Shadows Into Light: Art and Culture of the Northwest's Early Asian/
Pacific Community*, ed. Mayumi Tsutakawa and Alan Chong Lau (Seattle: Young Pine Press, 1982),
9–32; Kazuko Nakane with Alan Chong Lau, "Shade and Shadows: An Asian American Vision Behind
Northwest Lenses," *International Examiner* 18, no. 2 (January 23, 1991): special supplement, 1–12; Carole
Glauber, *Witch of Kodakery: The Photography of Myra Albert Wiggins, 1869–1956* (Pullman: Washington
State University Press, 1997); David F. Martin, *Pioneer Women Photographers: Myra Albert Wiggins,
Adelaide Hanscom Leeson, Imogen Cunningham, Ella E. McBride* (Seattle: Frye Art Museum, 2002);
Kazuko Nakane, "Facing the Pacific: Asian American Artists in Seattle, 1900–1970," in *Asian American
Art: A History, 1850–1970*, ed. Gordon H. Chang, Mark Dean Johnson, and Paul J. Karlstrom (Stanford:
Stanford University Press, 2008), 55–81; Lawrence Kreisman and Glenn Mason, "Photography with a
Softer Focus," chap. 11 in *The Arts and Crafts Movement in the Pacific Northwest* (Portland, OR: Timber
Press, 2007), 311–32; Terry Toedtemeier and John Laursen, *Wild Beauty: Photographs of the Columbia
River Gorge, 1867–1957* (Corvallis: Oregon State University Press, 2008); David F. Martin and Nicolette
Bromberg, *Shadows of a Fleeting World: Pictorial Photography and the Seattle Camera Club* (Seattle:
University of Washington Press, 2011).

2 Numerous scholars have commented on the large number of women who took up photography in the
late 19th and early 20th centuries, both as amateurs and professionals. They have suggested various
social and cultural reasons, including the ready accessibility and ease of use of cameras by that period
and the opportunities for income offered by photography. For further discussion see, for example,
Bronwyn A. E. Griffith, "'Dainty and Artistic or Strong and Forceful—Just As You Wish': American
Women Photographers at the Universal Exposition of 1900," in *Ambassadors of Progress: American
Women Photographers in Paris, 1900–1901*, ed. Bronwyn A. E. Griffith (Giverny: Musée d'Art Américain
Giverny, in association with the Library of Congress, Washington, DC, 2001), 12–15; Martin W. Sandler,
Against the Odds: Women Pioneers in the First Hundred Years of Photography (New York: Rizzoli,
2002); Christian A. Peterson, *After the Photo-Secession: American Pictorial Photography, 1910–1955*
(Minneapolis: Minneapolis Institute of Arts in association with W. W. Norton, New York, 1997), 103–6.

3 Several photographic experiments were underway in the early 1800s but with limited success. The start-
ing points for all subsequent development were two processes announced in 1839—the daguerreotype,
invented by Louis Jacques Mandé Daguerre in France, and the calotype by William Henry Fox Talbot
in England. Two of the classic texts on the history of photography are Beaumont Newhall, *The History
of Photography, from 1839 to the Present*, 5th ed. (New York: Museum of Modern Art, 1982), and Naomi
Rosenblum, *A World History of Photography*, 3rd ed. (New York: Abbeville Press, 1997), but there are
numerous other references on the technological and artistic histories of photography.

4 The two early techniques that were most commonly used were the daguerreotype and the wet collodion
process. To create a daguerreotype, a silver plate was coated with silver iodide and placed in a camera.
The image was taken and then the plate was exposed to mercury vapors that brought out the image that
had formed in the silver iodide from exposure to light. The wet collodion, or wet-plate collodion, process
involved coating a glass plate with a mixture of iodide and collodion (cellulose nitrate) and then immers-
ing it in a solution of silver nitrate. The wet plate was put in the camera, the image was taken, and it was
then developed and fixed by pouring over it an acid solution followed by a potassium cyanide solution.
The plate had to be processed immediately while the collodion was still wet or it was unusable.

5 There are numerous sources on the debate over photography as an art form, including Rosenblum,
World History of Photography, 209–14. Two key sources that discuss it in detail in relationship to

pictorialism are Peterson, *After the Photo-Secession*, and Patrick Daum, Francis Ribemont, and Phillip Prodger, *Impressionist Camera: Pictorial Photography in Europe, 1888–1918* (London and New York: Merrell; Saint Louis: Saint Louis Art Museum, 2006). One key period source was an article by the critic Sadakichi Hartmann, "Aesthetic Activity in Photography," published in *Brush and Pencil* 14, no. 1 (April 1904): 24–53.

6 See, for example, the discussion in Peterson, *After the Photo-Secession*, 9, on the classist roots of the American Photo-Secession, and Kristina Lowis, "European Pictorial Aesthetics," in Daum, Ribemont, and Prodger, *Impressionist Camera*, 47–53.

7 Rosenblum, *A World History of Photography*, 211.

8 See, for example, Crystal Leah Medler, "Certainty in the Uncertainty of Venice: John Ruskin and the Daguerreotype Photographic Process" (master's thesis, University of Pennsylvania, 2010), which details his complex relationship to photography, http://repository.upenn.edu/cgi/viewcontent .cgi?article=1148&context=hp_theses.

9 Peterson, *After the Photo-Secession*, 131–42.

10 Patrick Daum, "Unity and Diversity in European Pictorialism," in Daum, Ribemont, and Prodger, *Impressionist Camera*, 18, and Lowis, "European Pictorial Aesthetics," 47–48.

11 Many accounts of the Photo-Secession note that membership was so controlled by Stieglitz's personal preference that some artists were unaware they were considered members. See, for example, Peterson, *After the Photo-Secession*, 14.

12 Peterson, *After the Photo-Secession*, 101.

13 Bonnie Yochelson, "Clarence H. White: Peaceful Warrior," in *Pictorialism into Modernism: The Clarence H. White School of Photography*, ed. Marianne Fulton (New York: Rizzoli/George Eastman House with Detroit Institute of Arts, 1996), 10–119.

14 Yochelson, "Clarence H. White: Peaceful Warrior," 14.

15 The Darius and Tabitha Kinsey collection at the Whatcom Museum in Bellingham, Washington, contains more than 4,700 negatives and 600 prints from 50 years of their business.

16 There is currently no comprehensive overview of the early history of photography in Oregon, though descriptions of various aspects can be found throughout Glauber, *Witch of Kodakery*, and Toedtemeier and Laursen, *Wild Beauty*. See also Thomas Robinson, *Oregon Photographers: Biographical History and Directory, 1852–1917* (Portland: Thomas Robinson, 1992); Terry Toedtemeier, "Oregon Photography: The First Fifty Years," *Oregon Historical Quarterly* 94, no. 1 (Spring 1993): 36–76; Carole Glauber, "Eyes of the Earth: Lily White, Sarah Ladd, and the Oregon Camera Club," *Oregon Historical Quarterly* 108, no. 1 (Spring 2007): 34–67; Kreisman and Mason, *The Arts and Crafts Movement in the Pacific Northwest*, 311–32.

17 Glauber, *Witch of Kodakery*; Martin, *Pioneer Women Photographers*; Toedtemeier and Laursen, *Wild Beauty*, 153–57.

18 Toedtemeier and Laursen, *Wild Beauty*, 153.

19 Kreisman and Mason, *The Arts and Crafts Movement in the Pacific Northwest*, 317.

20 Monroe, "Light and Shade," 12; David F. Martin, "Painted with Light," in Martin and Bromberg, *Shadows of a Fleeting World*, 24.

21 Kreisman and Mason, *The Arts and Crafts Movement in the Pacific Northwest*, 314.

22 Nakane and Lau, "Shade and Shadows," 3.

23 Barbara A. Davis, *Edward S. Curtis: The Life and Times of a Shadow Catcher* (San Francisco: Chronicle Books, 1985).

24 Martin, "Painted with Light," 22.

25 Martin, "Painted with Light," 12.

26 Martin, "Painted with Light," 18.

27 For a detailed biography of McBride, see David F. Martin's essay in this catalogue; Martin and Bromberg, *Shadows of a Fleeting World*, 141–45; and David F. Martin, "McBride, Ella E. (1862–1965)," March 3, 2008, HistoryLink.org, http://www.historylink.org/File/8513.

28 Davis, *Edward S. Curtis*, 54. See also the discussion of Curtis and McBride's relationship in David F. Martin's essay in this catalogue.

29 Martin and Bromberg, *Shadows of a Fleeting World*, 86–88.

30 Martin and Bromberg, *Shadows of a Fleeting World*, 166–68.

31 Martin, "Painted with Light," 32.

32 Walter B. Pitkin, *Careers after Forty* (New York and London: Whittlesey House, 1937), 217.

33 Martin and Bromberg, *Shadows of a Fleeting World*, 142.

34 Martin and Bromberg, *Shadows of a Fleeting World*, 86.

35 Kyo Koike, "The Influence of Old Japanese Literature and Arts on Pictorial Photography," *American Photography* 22, no. 1 (January 1928): 16–19.

36 Tsutakawa and Lau, *Turning Shadows Into Light*; Dennis Reed, "The Wind Came from the East: Asian American Photography, 1850–1965," in Chang, Johnson, and Karlstrom, *Asian American Art: A History*, 148.

37 Martin, "Painted with Light," 37–38.

38 Daum, "Unity and Diversity in European Pictorialism," 16.

39 Martin, "McBride, Ella E. (1862–1965)."

40 See the essay by David F. Martin in this catalogue for further information on Goon Dip and Ella McBride's meeting and subsequent friendship.

Plates

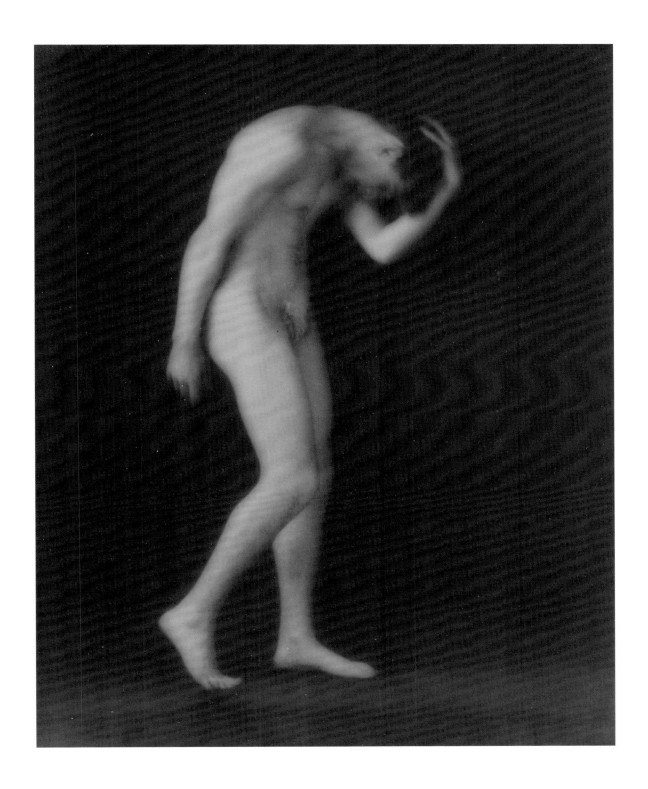

PLATE 1
Cain, 1921

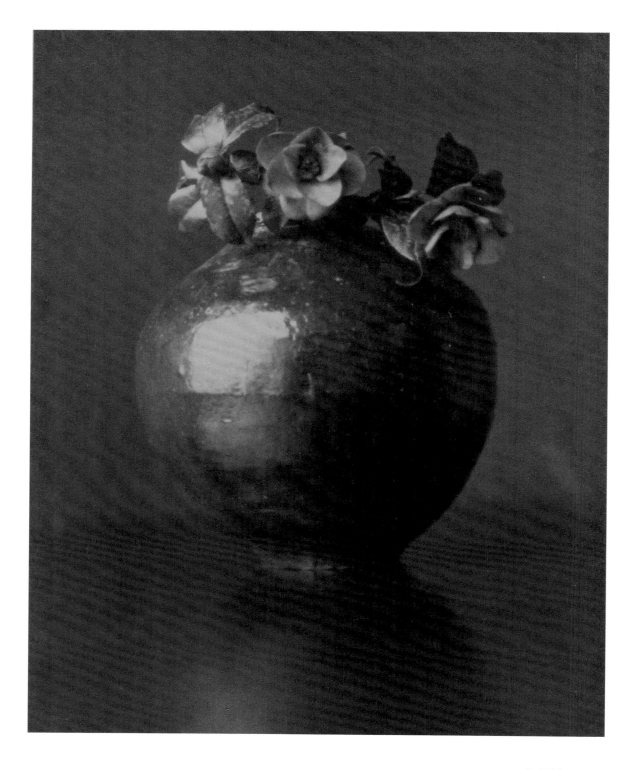

PLATE 2
Chinese Jar with
Camellias, 1921

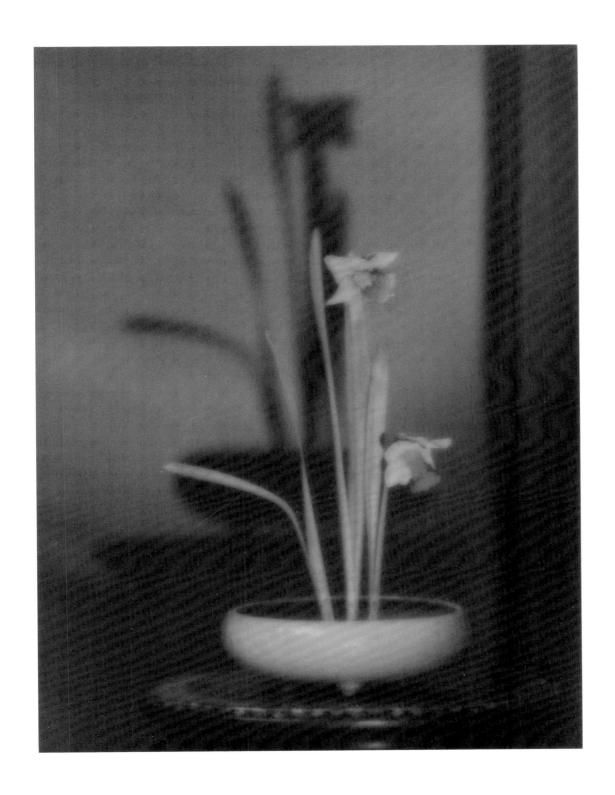

PLATE 3
Daffodils, 1921

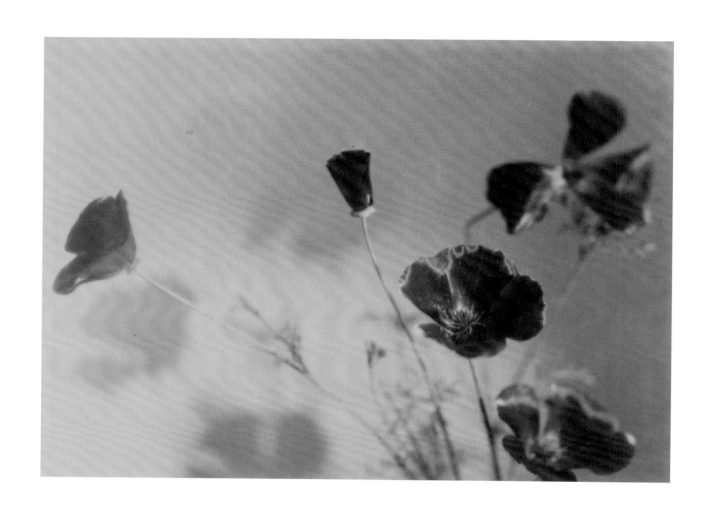

PLATE 4
Poppies, 1921

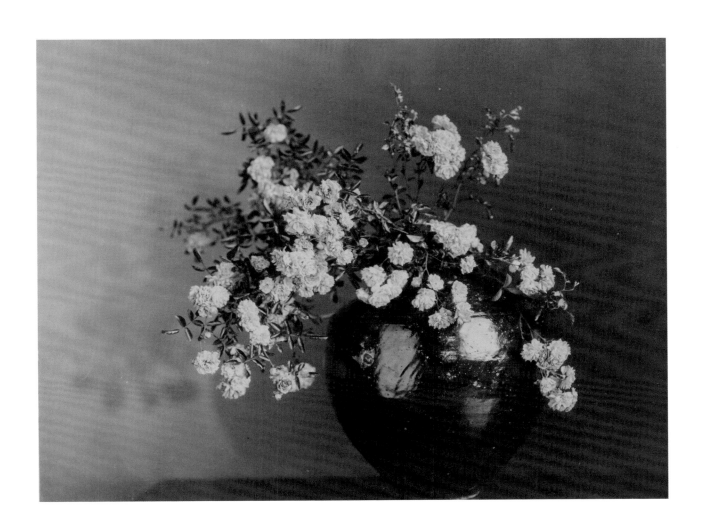

PLATE 5
Untitled (miniature
roses), ca. 1921

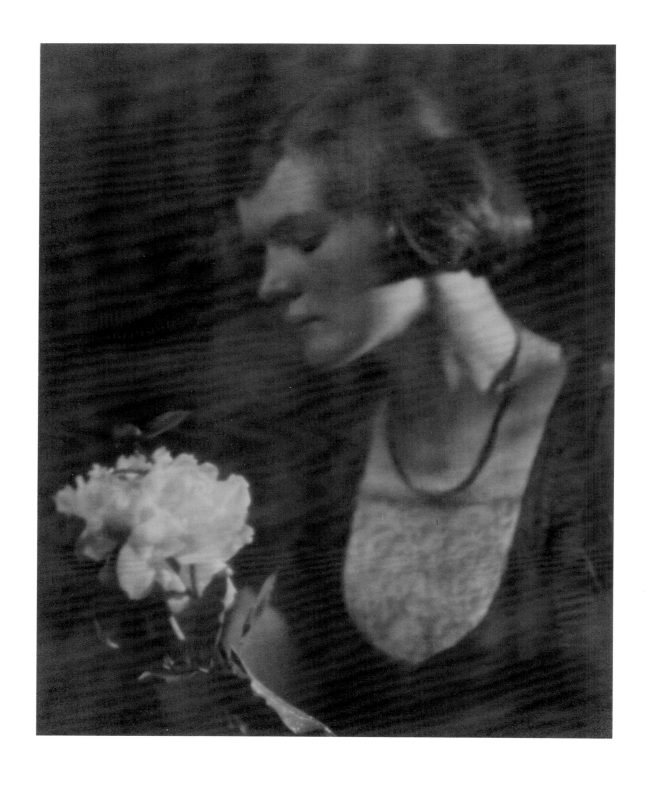

PLATE 6
Dorothy, ca. 1921

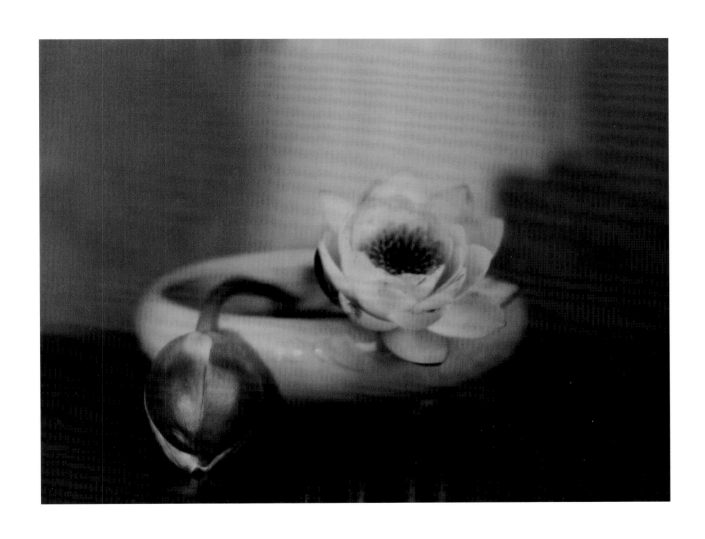

PLATE 7
Life and Death, ca. 1921

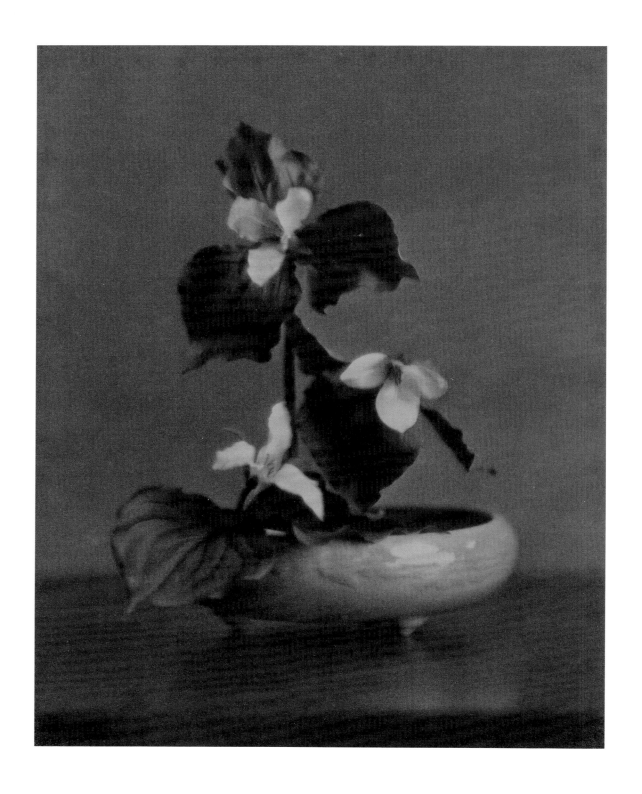

PLATE 8
Trillium, ca. 1921

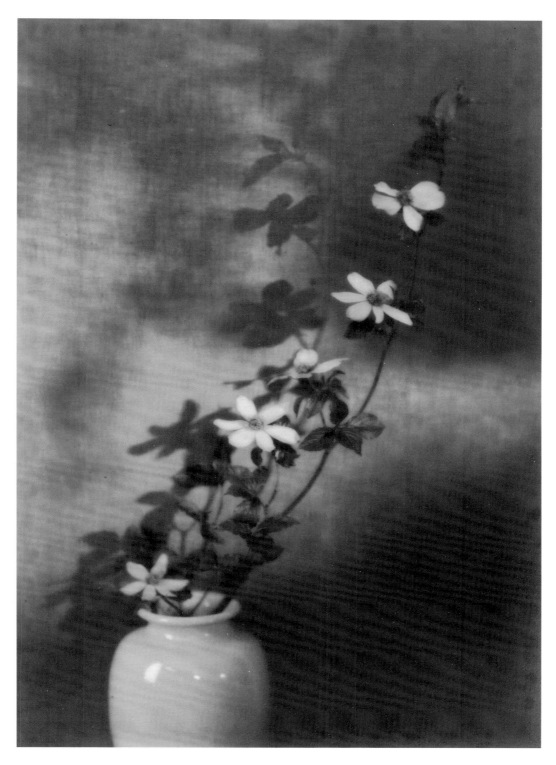

PLATE 9
Dogwood, ca. 1921

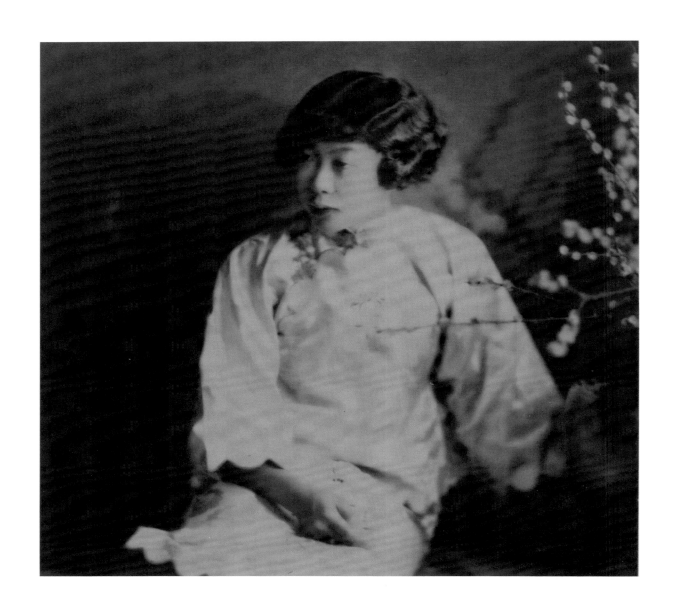

PLATE 10
Untitled (portrait of
unidentified woman),
ca. 1921

PLATE 11
Untitled (self-portrait
with camera shadow),
ca. 1921

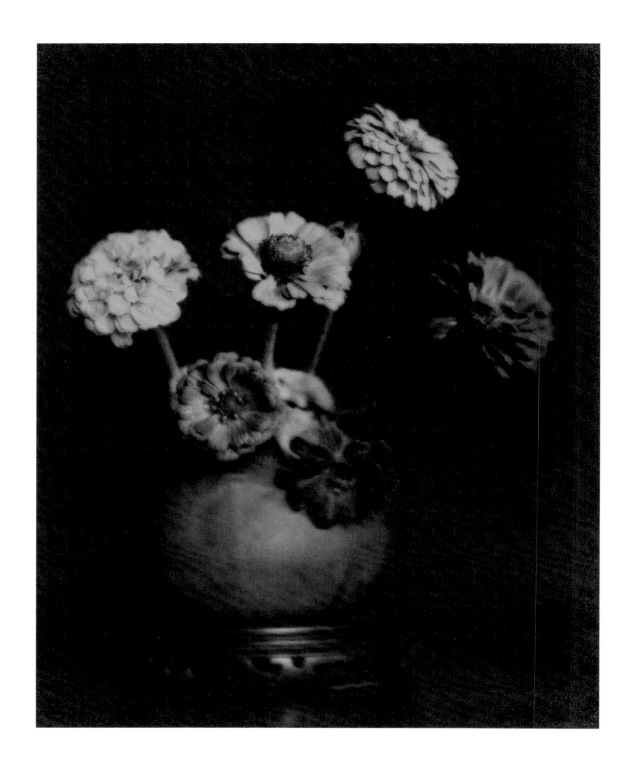

PLATE 12
Zinnias, ca. 1921

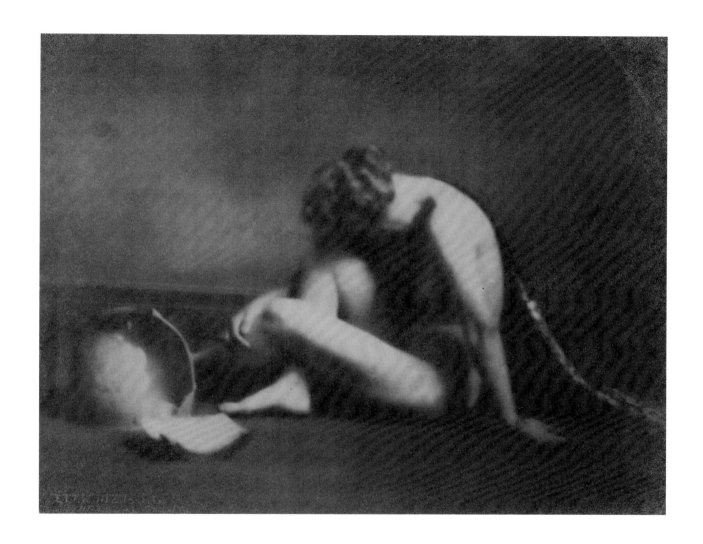

This photograph was inspired by a poem written by McBride's
friend Elizabeth Sander Lilly, a photographer and mountaineer:

I poured my dreams into the bowl
That was your heart,
Splashing their magic joys with lavish hands.
The bowl was made of earth,
And fell apart—
Spilling my dreams upon the lonely sands.

PLATE 13
The Broken Bowl,
ca. 1922

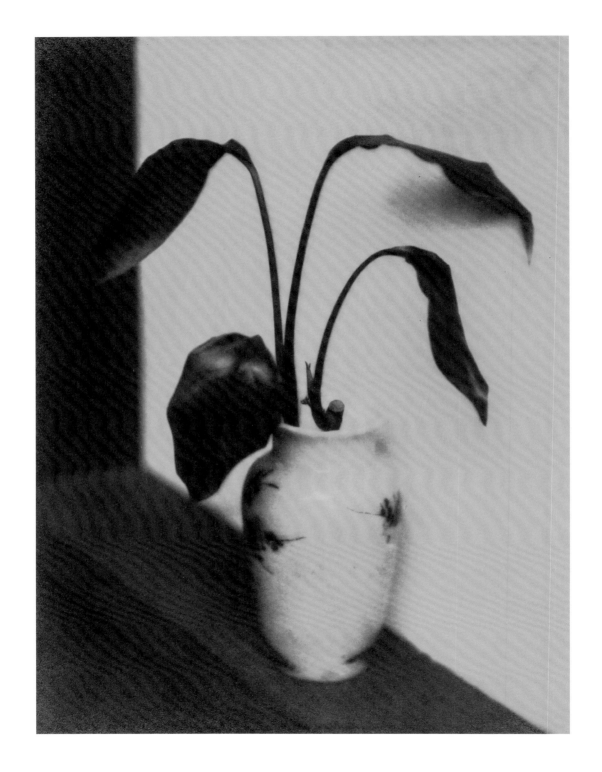

PLATE 14
Chinese Water Plant,
ca. 1922

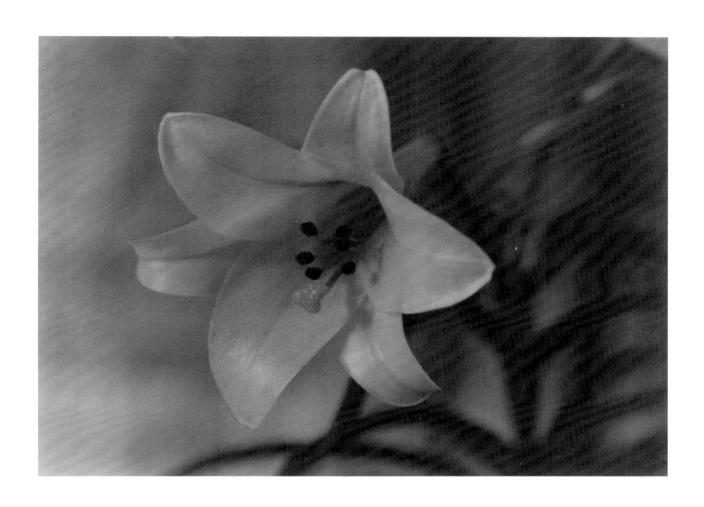

PLATE 15
Eastertide, ca. 1922

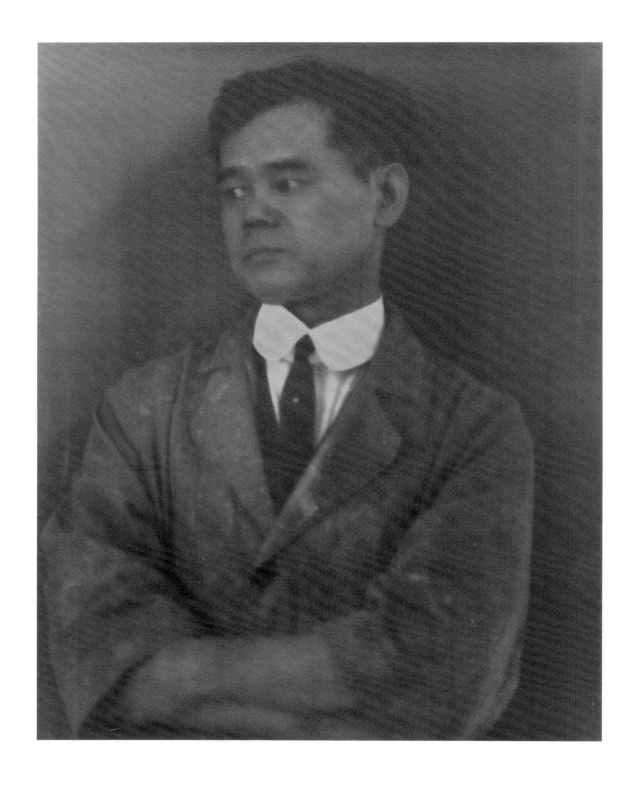

PLATE 16
F. A. Kunishige, ca. 1922

PLATE 17
In the Spring, ca. 1922

PLATE 18
Magnolia, ca. 1922

PLATE 19
Old Chinese Wine Jar,
ca. 1922

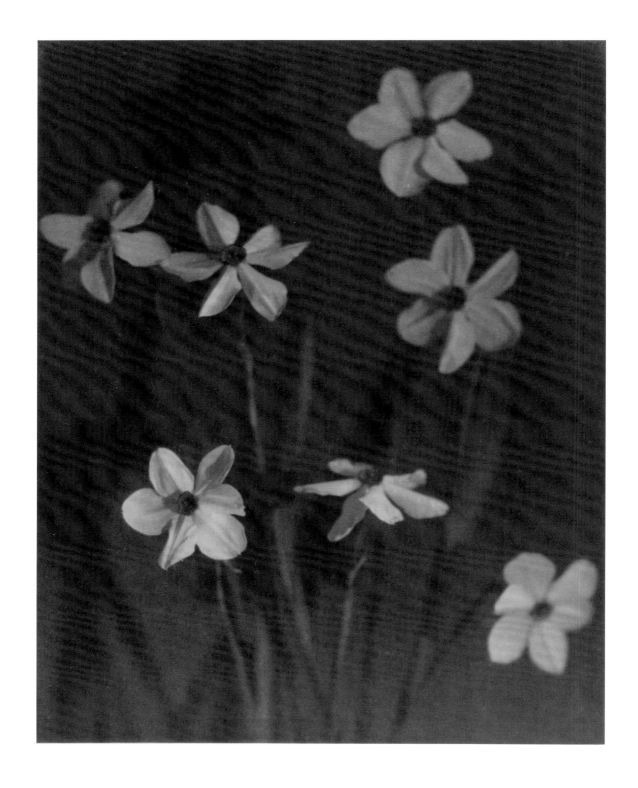

PLATE 20
A Pattern, ca. 1922

92

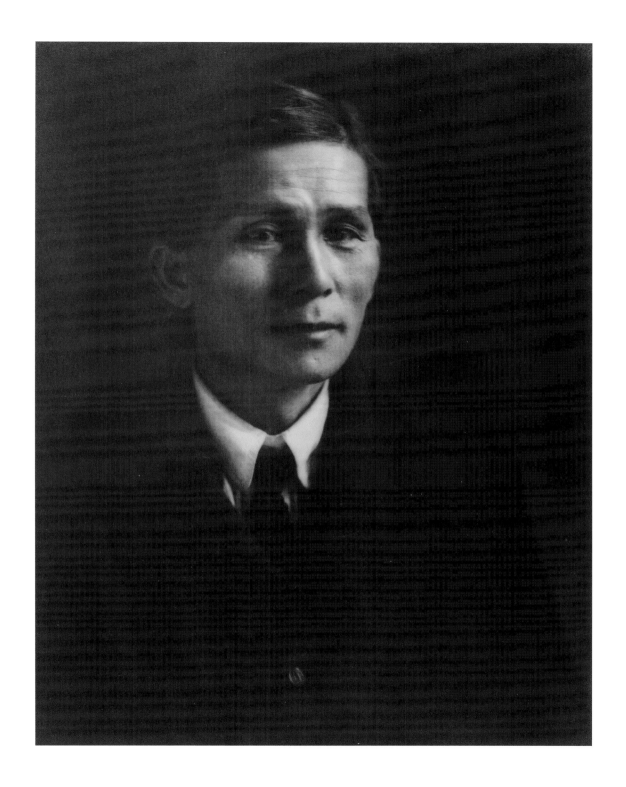

PLATE 21
A Study, ca. 1922

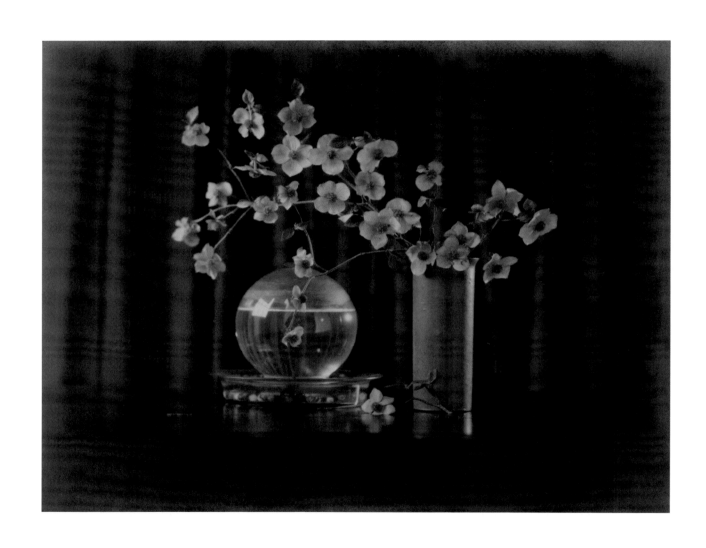

PLATE 22
Untitled (dogwood),
ca. 1922

PLATE 23
Untitled (elephant ear
leaves), ca. 1922

PLATE 24
Untitled, ca. 1922

PLATE 25
Untitled, ca. 1922

PLATE 26
Untitled, ca. 1922

PLATE 27
Untitled (wisteria),
ca. 1922

PLATE 28
Leaving the Temple, 1924

100

PLATE 29
Untitled, 1924

PLATE 31
As They Grow, ca. 1924

PLATE 33
Child in Iris Garden,
ca. 1924

PLATE 34
*Eryngium—An
Arrangement,* ca. 1924

PLATE 35
Leaves, ca. 1924

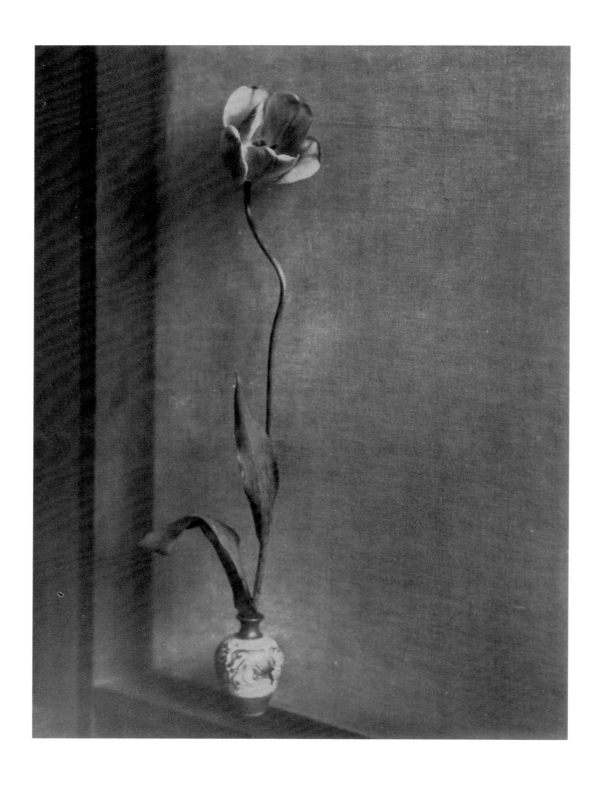

PLATE 36
The Magic Vase, ca. 1924

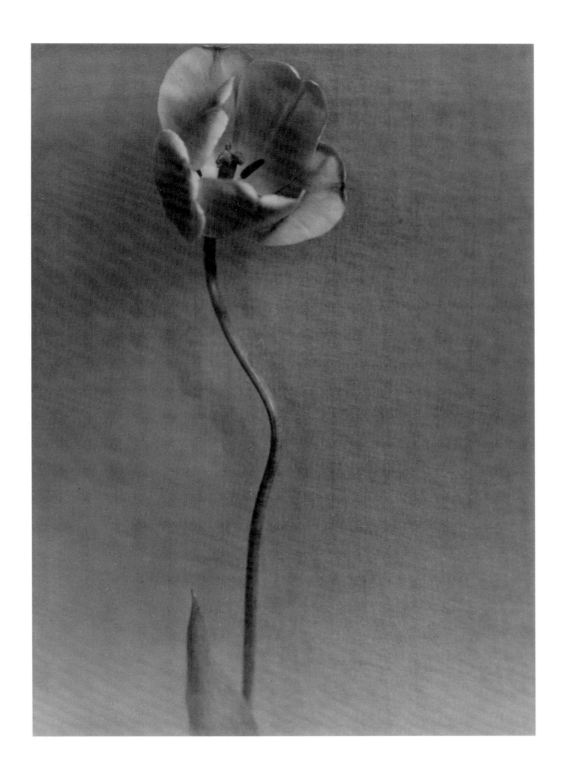

PLATE 37
Portrait of a Tulip,
ca. 1924

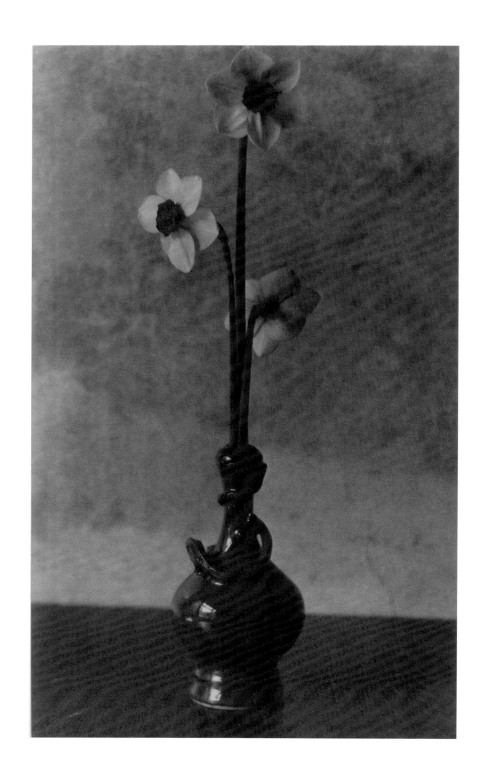

PLATE 38
Untitled (narcissus),
ca. 1924

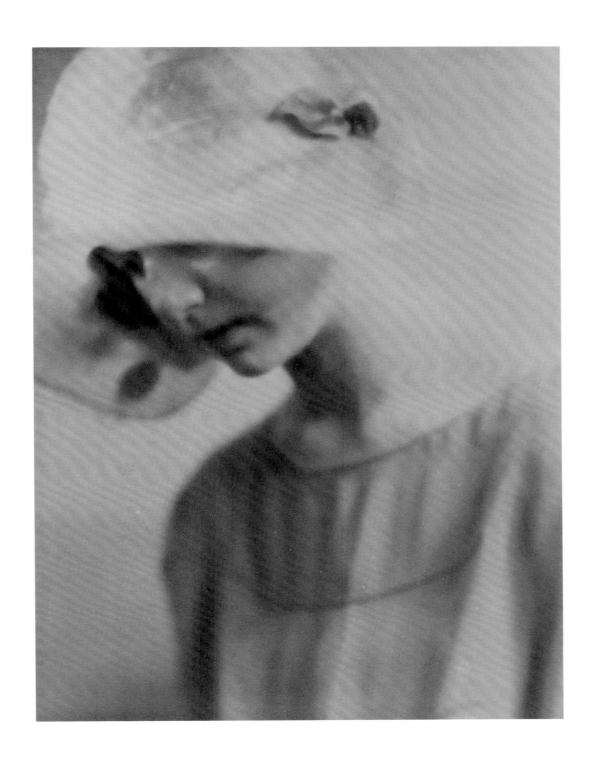

PLATE 39
Untitled (Betti
Morrison), ca. 1924

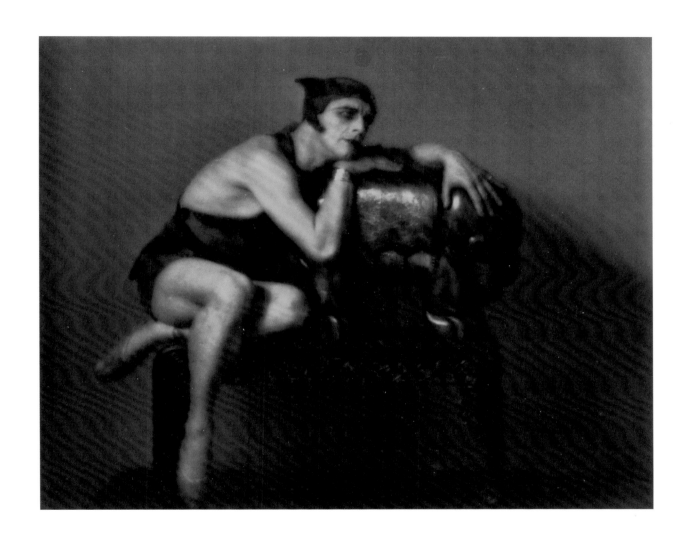

PLATE 41
Untitled (Adolph Bolm),
ca. 1922–24

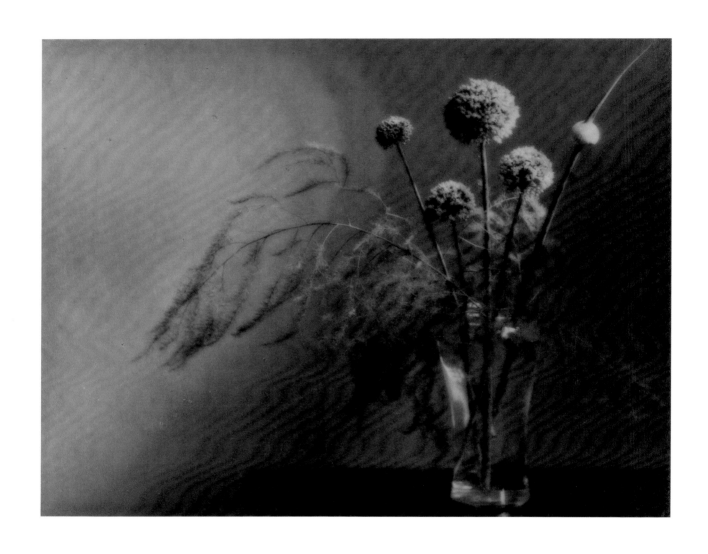

114

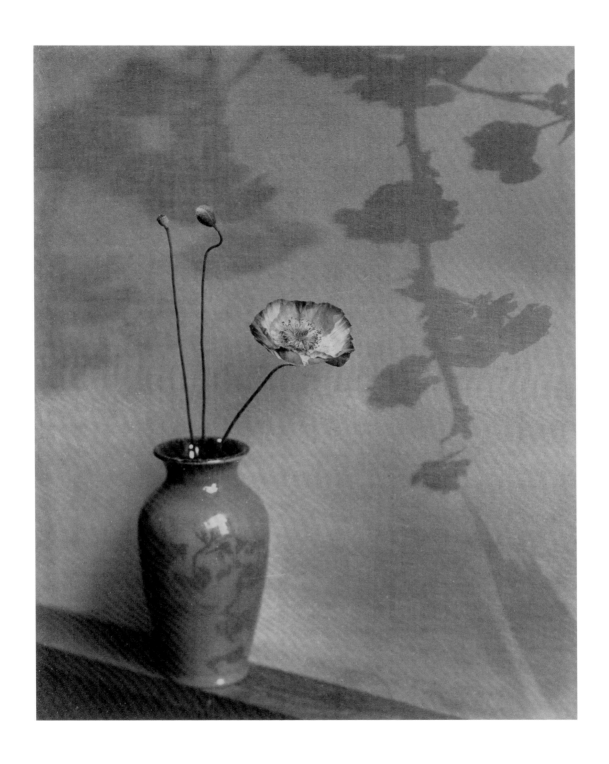

PLATE 43
A Shirley Poppy, 1925

PLATE 44
The Silver Pitcher, 1925

PLATE 45
Silver Pitcher, ca. 1925

PLATE 46
Untitled (cherry
blossoms), 1925

PLATE 47
In Port, ca. 1925

PLATE 48
Midsummer, ca. 1925

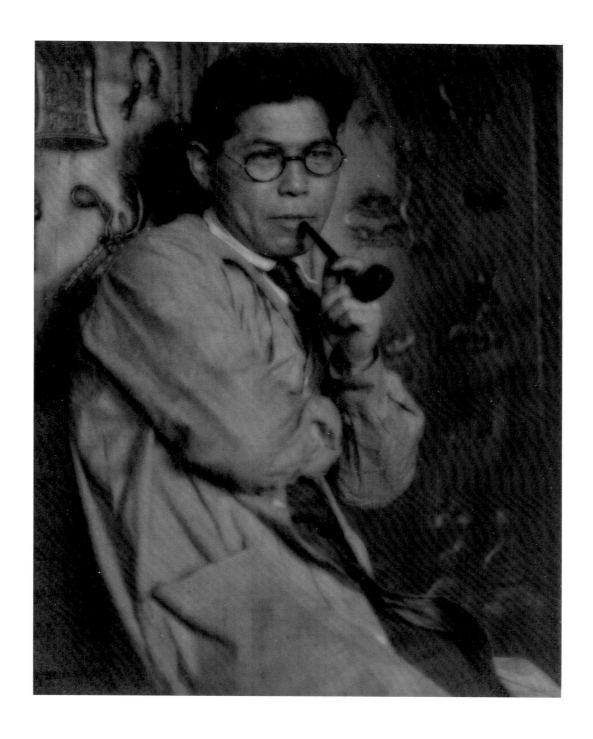

PLATE 49
Reverie, ca. 1925

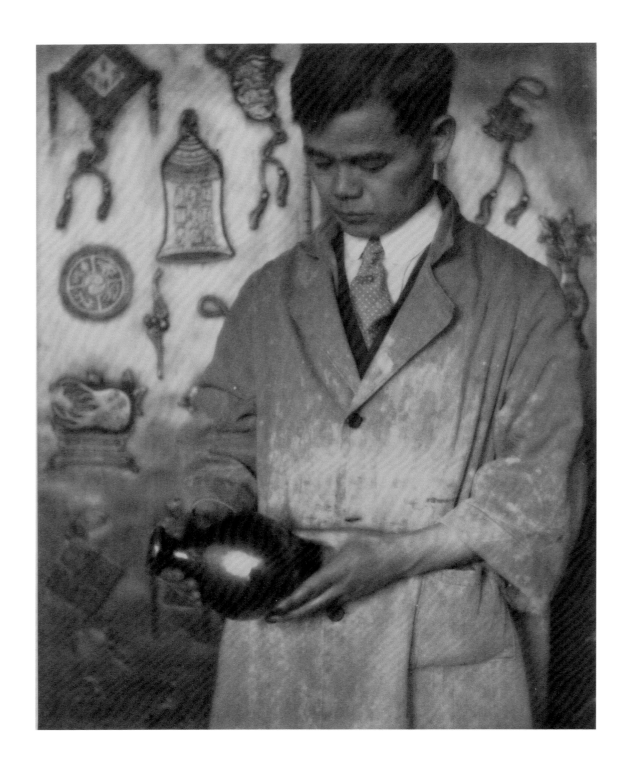

PLATE 50
The Connoisseur,
ca. 1925

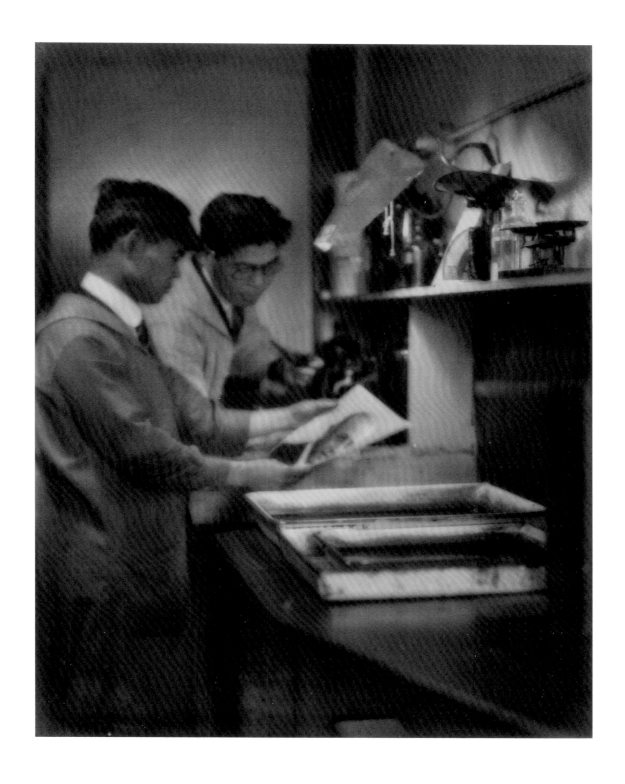

PLATE 51
Judging a Print, ca. 1926

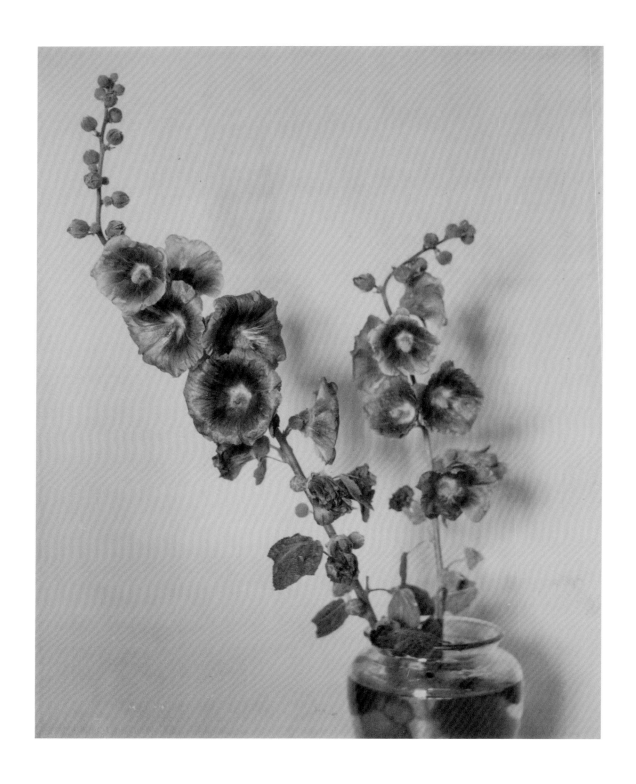

PLATE 52
Red Hollyhocks, ca. 1927

PLATE 53
Untitled (Roi Partridge),
ca. 1927

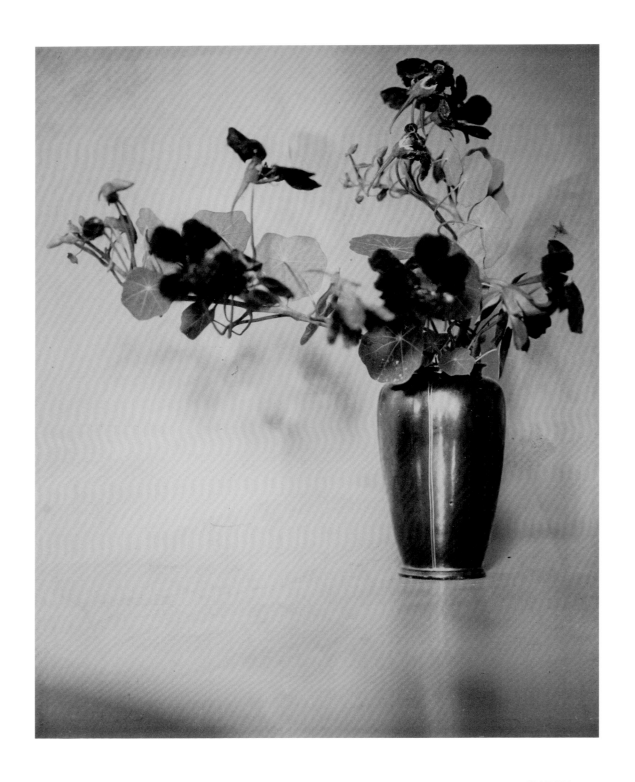

PLATE 54
Untitled (nasturtiums),
date unknown

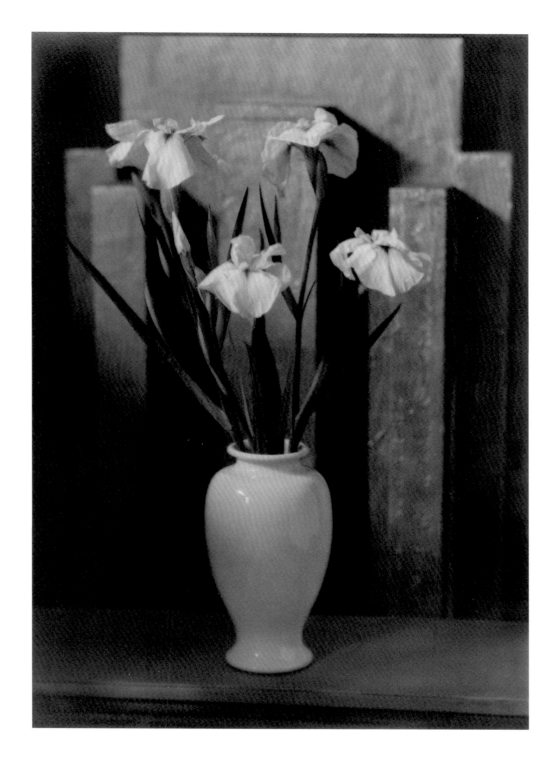

PLATE 55
Untitled (irises),
date unknown

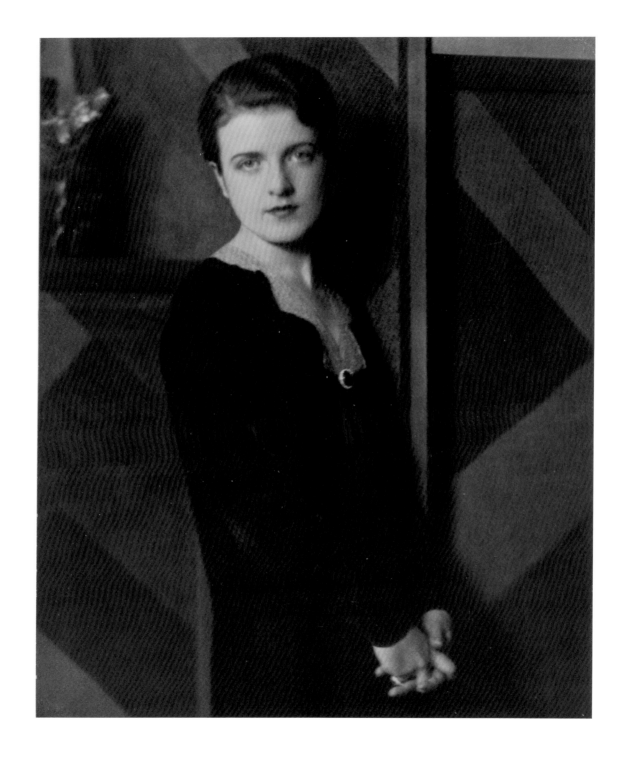

PLATE 56
Untitled (portrait of
unidentified woman),
date unknown

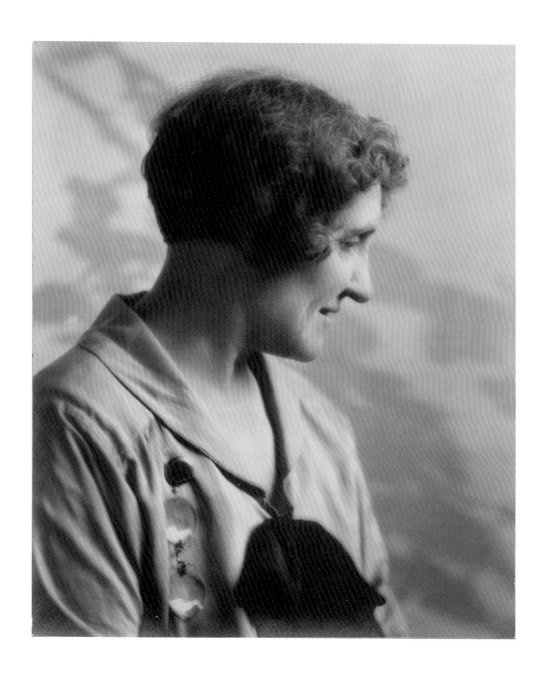

PLATE 57
WAYNE ALBEE
(American, 1882–1937)
Ella McBride, ca. 1920

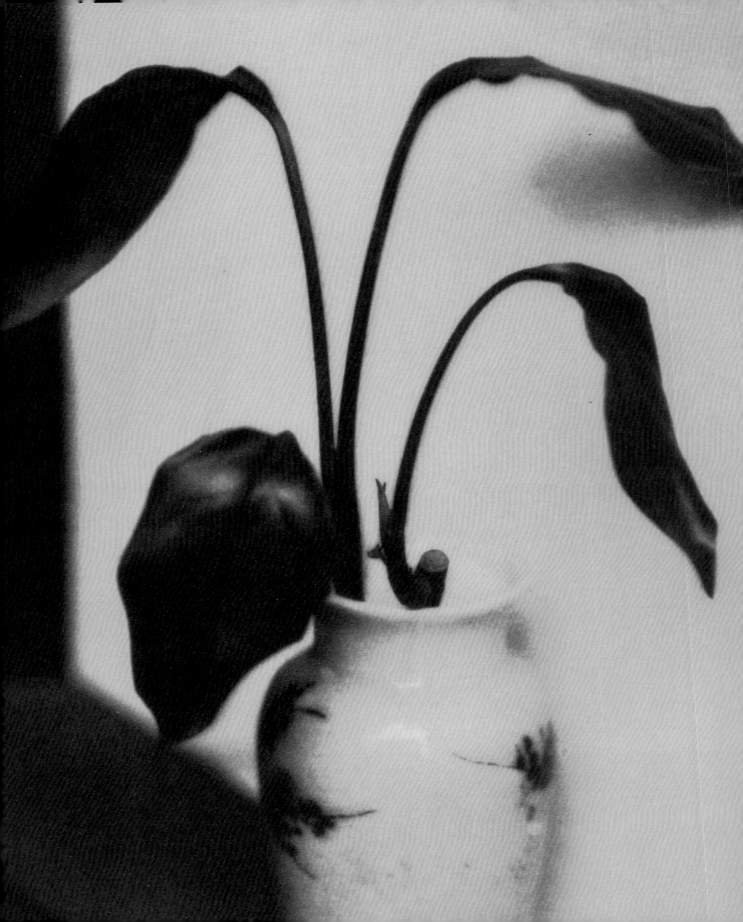

Exhibition Checklist

Unless otherwise indicated, all works are by Ella E. McBride (American, 1862–1965).

Dimensions reflect the image size; height precedes width.

This checklist follows a chronological order supported by historical evidence.

Cain, 1921
Gelatin silver print
9 ⅜ × 7 ½ in.
Private collection
Plate 1

Chinese Jar with Camellias, 1921
Gelatin silver print on Textura tissue
9 ½ × 7 ½ in.
Tacoma Art Museum, Gift of Richard Anderson
and Martin-Zambito Fine Art, 2002.15.7
Plate 2

Daffodils, 1921
Gelatin silver print on Textura tissue
9 ⅝ × 7 ⅛ in.
Private collection
Plate 3

Poppies, 1921
Gelatin silver print
6 × 9 ⅝ in.
Private collection
Plate 4

Dogwood, ca. 1921
Gelatin silver print
13 ⅜ × 9 ¼ in.
Los Angeles County Museum of Art,
Los Angeles County Fund, 28.23.2
Plate 9

Dorothy, ca. 1921
Gelatin silver print
9 ½ × 7 ⅝ in.
Private collection
Plate 6

Life and Death, ca. 1921
Gelatin silver print
7 ½ × 9 ¾ in.
University of Washington Libraries, Special
Collections, Janet Anderson Collection,
UW 38934
Plate 7

Trillium, ca. 1921
Gelatin silver print on Textura tissue
9 ½ × 7 ½ in.
Private collection
Plate 8

Untitled (miniature roses), ca. 1921
Gelatin silver print
10 ⅜ × 13 ⅝ in.
Private collection
Plate 5

Untitled (portrait of unidentified woman),
ca. 1921
Gelatin silver print
8 ¾ × 9 ⅜ in.
Private collection
Plate 10

Untitled (self-portrait with camera shadow),
ca. 1921
Gelatin silver print
9 ¾ × 7 ⅜ in.
University of Washington Libraries, Special
Collections, Janet Anderson Collection,
UW 38940
Plate 11

Zinnias, ca. 1921
Gelatin silver print on Textura tissue
9 ⅝ × 7 ½ in.
Private collection
Plate 12

The Broken Bowl, ca. 1922
Gelatin silver print on Textura tissue
7 ½ × 9 ½ in.
Private collection
Plate 13

Chinese Water Plant, ca. 1922
Gelatin silver print on Textura tissue
13 ⅜ × 10 in.
Private collection
Plate 14

Eastertide, ca. 1922
Gelatin silver print
7 ⅛ × 9 ⅝ in.
Private collection
Plate 15

F. A. Kunishige, ca. 1922
Gelatin silver print
9 ⅝ × 7 ⅝ in.
Private collection
Plate 16

In the Spring, ca. 1922
Gelatin silver print on Textura tissue
9 ⅝ × 7 ½ in.
Private collection
Plate 17

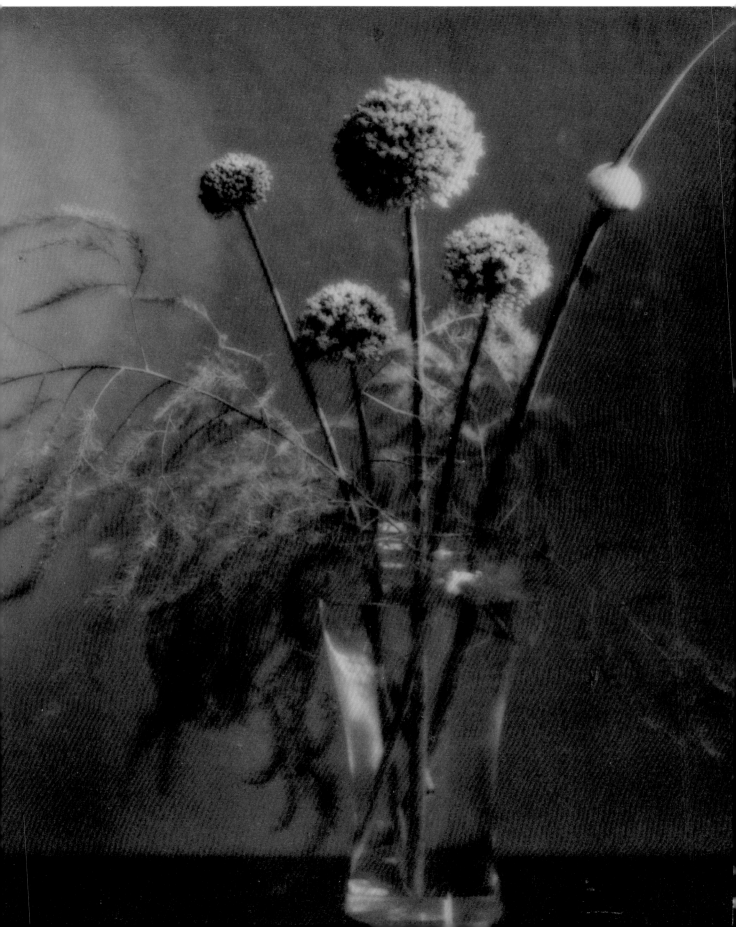